CREATIVE SUNPRINTING

CREATIVE SUNPRINTING

*Early photographic printing
processes rediscovered*

Peter Fredrick

Focal Press · London

Focal Press Inc. · New York

© FOCAL PRESS LIMITED 1980

British Library Cataloguing in Publication Data

Fredrick, Peter
 Creative sunprinting
 1. Photography – Printing processes –
 Amateurs' manuals
I. Title
 770'.284 TR330 79–41443

ISBN (excl. USA) 0 240 51045 3
ISBN (USA only) 0 8038 1269 8

First edition 1980

Printed in Great Britain by
M. & A. Thomson Litho Ltd., East Kilbride, Scotland

Contents

Foreword

This book will be received enthusiastically by those photographers who firmly believe that the printing of the negative is a vitally important stage in the total process of the production of a photograph.

For far too long the photographic manufacturers have provided a very limited range of printing papers, thereby severely curtailing possibilities for creative printing and reducing the visual and tactile variations, at one time obtainable in respect of tonality, colour range, surface texture and sheen. Each year it seems that yet one more of the limited number of alternatives is discontinued and that we have arrived, to all intents and purposes, at a dreary uniformity in respect of available photographic printing papers. The effect of this is to reduce monochromatic photographs to a visual 'same-ness' which is boring in the extreme.

A large part of the pleasure of photography for many practitioners is in the making of the print. This pleasure reached its zenith during the last decade of the nineteenth century and lasted until the outbreak of the First World War. During those years artist photographers prepared their own papers and practised a large range of printing processes, printing being regarded as an integral part of the creative process of making a photograph. Their achievements can still be seen in several of our major collections. These prints are particularly significant in that many of the processes then practised were permanent and, as a result, the images are as fresh and lively as when the prints were made. The richness of a good carbon print, whether it be sanguine, blue or vandyke brown has to be seen to be believed. The remarkable variation in tonal emphasis and textural qualities which can be achieved with gum printing cannot be adequately described in words. The delicate subtleties in a superb platinum print are unsurpassable. The modest silver print is an object of beauty.

Peter Fredrick, in this admirable book, brings these old processes to life for us. Its publication is timely as many photographers, who are thoroughly dissatisfied with the present day products of the manufacturers, would dearly love to engage in the fascinating pursuit of sun-printing but lack courage and experience.

The author does not pretend that any of the processes offer short cuts to success. Instead he stresses the fun and enjoyment to be found

7

in 'taking part in a uniquely creative activity'. He is a remarkably skilled practitioner and not only conveys his considerable enthusiasm but also passes on his unique experience to us. In particular he promotes the entirely new concept of colour synthesis: 'flat colour assemblage' which frees the creative photographer from the constraints imposed by modern colour printing. Above all he makes no attempt to resurrect late nineteenth century forms of photographic imagery, but by his own example as well as in his writing he reveals that these beautiful methods of photographic printing can be used to interpret present day themes and creative ideas.

Margaret Harker

Acknowledgements

Firstly I must thank Professor Margaret Harker for all her support and encouragement, without which it is doubtful whether this book would ever have been written.

I must also thank John Howson for his remarkable drawings that have brilliantly caught the spirit of the text; colleagues Ian Dickens, Jane Hill, Roger Brown and Gordon Crawford, who have freely given advice; all the staff at Focal Press for their kind help and guidance; and, finally, my wife June and our children for putting up with my eccentric sunprinting behaviour with both love and patience.

Preface

When I first started to write this book it was conceived as a print-making workshop manual—a kind of sunprinting cook book, from which an interested photographer with a few simple utensils, such as a contact printing frame, a number of dishes, and an assortment of brushes, could start to make and sunprint his or her own materials, at the same time having a lot of fun and enjoyment taking part in a uniquely creative activity.

This is still the primary aim, but I found as the book grew and developed that the concept of sunprinting as a methodology separate from conventional creative photography, seemed to evolve, in the same way that fine art print-making differs from painting. The very nature of the process is the use of large format negatives, allowing considerable autographic inclusions, and the freedom to manufacture your own light sensitive materials to entirely personal specifications. This last facility came as quite a surprise, having been brought up in the tradition of using only manufactured light sensitive materials. It is only after making your own material, that you fully realise the stranglehold the photographic manufacturer has on the creative development of photography. Catalogues of print materials become slimmer and slimmer each year, and the materials produced are increasingly fugitive, so much so that there is considerable concern as to the archival permanence of the majority of modern photography. This is a ludicrous situation when one considers the quickening of public interest in the role of photography amongst the other visual arts, with public and private galleries springing up all over the world, creating a demand for the gallery print. Imagine the shock to owners of a piece of photographic art to find it staining and fading away before their very eyes in a few years. What is the point of carefully printing, mounting and framing an art photograph if the basic material is fugitive and unstable?

Here the sunprinting processes triumph. Most of these processes are reasonably stable. Even dye processes, traditionally the most fugitive,

9

are comparatively stable compared to their commercial counterparts. For real archival permanence the expensive platinotype and the more economic pigment processes reign supreme. For this reason the pigment processes have been given a lot of attention in this book, to make up for a great deal of neglect over the years. The processes, particularly the gum bichromate and oil processes, have been completely revised and new technical procedures adopted which should not only improve the image quality but also speed up and simplify their working.

If these latter processes are used, then photographs should last in good condition for many centuries. Each of the fourteen separate printing methods described in this book are capable of unique and personal image quality, allowing the creative sunprinter a kaleidoscopic choice of printed effect.

The essential part of any system of colour print-making relies heavily on the way the various colour layers make up the final coloured image. The motivating principle which underlies most of the modern methods of colour reproduction is based on trichromatic synthesis.

A campaign is fought in this book for an entirely new concept of colour synthesis, to be known as flat colour assemblage; a process that frees the creative worker from the constraints inherent in the more common trichromatic method.

Aesthetic and historical perspectives are included where they are required to give balance to the more technical aspects of the book. History is always fascinating, particularly as most of the creative sun-printing processes were developed during the birth pangs of photography as an image-making process. Most of these early processes were developed by dedicated amateurs before the days of enormous research programmes. These strictly private enterprises achieved remarkable individual feats of creative thought and action.

Time and again in this book great stress is laid on a personal approach to creative sunprinting, even to the point of being repetitive. I make no excuse for this attitude, as I firmly believe that the prime constituent for all truly creative work lies in the awakening of individual consciousness. Blind copying of other photographers' work is not only immoral, but more importantly, totally ineffective, even if those photographers happen to be masters of the photographic art. Only by slow, patient and sometimes painful, experimental work, linked to considerable visual research, will the photographer achieve anything worthwhile. There are no short cuts, or easy paths, each will have to find his or her own way.

Technique, although essential, is only part of the creative act. Aesthetic, historical and social influences must also be taken into account to give richness and quality to the creative concept. The final sunprint must contain an harmonic balance between what is deeply felt and what is understood and known.

1. Photographic Preparation

Introduction Sunprinting is open to all, but it does help if the potential sunprinter has a basic knowledge of photography, the ability to use a camera in a creative manner and a reasonable competence in photographic technique, such as negative development, contact and projection printing, all of which are necessary to fully exploit this medium.

In addition, chemicals have to be made up into simple mixtures. These formulae are very straightforward to prepare. This book is based on the concept of simple efficient technique, allowing a great amount of personal freedom of expression. The equipment and materials described are cheap to purchase and very easy to use. Most of the sunprinting processes use materials which are readily available and can be purchased from drugstores, general food stores and artists' supply shops. Where chemicals of an unusual nature need to be purchased, specialist suppliers are listed at the end of the book.

One of the most attractive features of sunprinting lies in the simplicity of large scale contact printing. Apart from contact printing frames, the only equipment necessary is a few dishes, a glass measure, some spoons, and an assortment of brushes, including a latex foam painting roller. There are other items of equipment, related to the specialist requirements of a particular process, but these items should be cheap to acquire or make.

A sunprinting workshop is necessary for the basic preparation and coating of light sensitive binders onto base materials, also some form of processing area is required. Any workroom is suitable as long as it is clean; dust is always the great enemy. A sink with running water is ideal, plus a workbench surfaced with glass or formica. A kitchen, bathroom, or preferably, a photographic darkroom could be used. A darkened room is not essential, as long as it is possible to exclude direct sunlight, as most of the sunprinting processes are extremely insensitive. Therefore, photographic safelighting is not required, normal household illumination is quite safe.

11

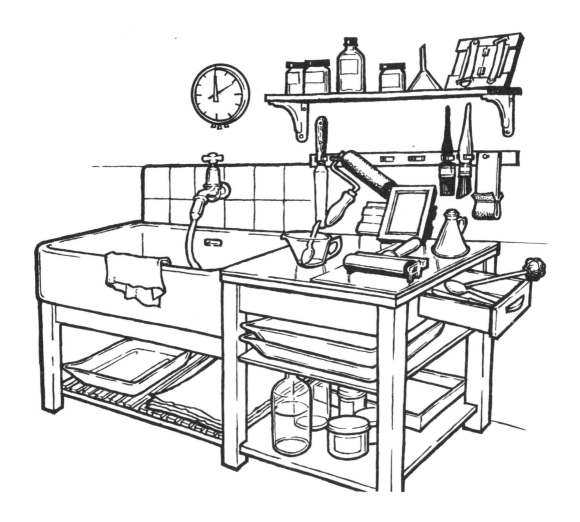

The original photography and the production of enlarged negatives necessary for the successful operation of the various sunprinting processes, of course, need normal photographic facilities for adequate preparation. There is no short cut to this basic requirement, unless the sunprinter farms out the preparation work to a commercial processing and printing laboratory, which would be more expensive.

Correct exposure in most of the sunprinting processes is assessed by observation of a print-out image, but one or two of the processes may require the use of a simple actinometer—an instrument which measures the exposure time required by the light source. To see the image slowly emerge is one of the most exciting attributes of this form of printing. The process of estimation of correct exposure sharpens visual sensitivity and the appreciation of fine tonal relationships.

The creative sunprinter becomes his own light sensitive materials manufacturer, and as such, prepares various coatings by compounding

the chemicals, binders and image colourants in correct proportions. Much time and creative effort is often wasted by *uncontrolled* experimentation. Remember that precise amounts of chemicals ought to be used. Do not add a little of this to some of that. A sloppy approach to the preparation of light sensitive coating can only spell disaster.

Coating procedure varies according to the process to be used. In some cases a number of differing methods are acceptable, but in others only one form of coating technique works efficiently. Each process described in this book comes with a recommended coating procedure. These processes have been, in many cases, personally evolved by the author after years of experimentation, and work if the procedure described is strictly adhered to.

Direct sunlight is the best form of light to be used for creative sunprinting, as the sun is an extremely actinic source of light. It is rich in just the right wavelengths of light, such as ultraviolet and blue, which cause the most rapid photochemical reaction. Daylight (diffused sunlight) and skylight are also effective but lack the energy of direct sunlight. The main advantage of natural light lies in the fact that it is of very high energy and, of course, free. It is also comparatively cool. Excessive heat tends to fog some of the light sensitive coatings used in sunprinting, notably the bichromated colloids.

Artificial light sources, on the other hand, are costly and rather weak in comparison to sunlight. The main advantage of these sources is that they have a constant output unlike daylight. Using artificial light, it is easy to make a precise measurement of time and intensity of illumination to assess exposure accurately. Conversely, it does radiate considerable infrared energy which can, on occasion, cause fogging troubles.

Careful photographic preparation is important for successful sunprinting, but strict adherence to technique must not be taken too far. Most of the processes have, in fact, a great deal of latitude in their operation, allowing a high degree of personal freedom of visual expression. Making images which have intrinsically unique characteristics, even when made from the same enlarged negative, provides the basic thrill which underlies much creative activity.

Enlarged Negatives Sunprinting processes are very insensitive to the effects of light compared to conventional photographic materials. Herein lies both the strength and the weakness of these processes.

Contact printing is the only feasible method of print-making because of the insensitivity to exposure. There are advantages to using this system of image-making. The method is mechanically faster than projection printing, and it is possible to print several negatives simultaneously, a feature impossible with projection printing. Correct exposure, once assessed, will tend to remain constant, as long as coating consistency is also maintained. The main disadvantage of contact print-

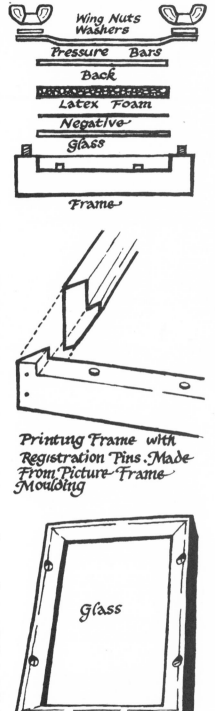

Wing Nuts
Washers
Pressure Bars
Back
Latex Foam
Negative
Glass
Frame

Printing Frame with Registration Pins. Made From Picture Frame Moulding

Glass

ing is that to produce a reasonable sized image, large negatives are necessary. Most modern photographers tend to use small to medium sized photographic equipment and formats. The amateur field is dominated by the 35mm format. An enlarged duplicate negative will, therefore, need to be made from either negatives or the ever popular 35mm colour slide. This method of producing large negatives by duplicating existing negatives or positives does offer a number of advantages. First, the contrast and density characteristics of a duplicate negative are easily controlled making it possible to produce a negative which ideally suits a particular sunprinting process. Secondly, the enlarged duplicate negative can incorporate a great deal of corrective printing and retouching, so that no tonal or detail correction is necessary in the final sunprinting stage, again simplifying the printing procedure.

The corrective work is undertaken at the intermediate positive stage and/or at the duplicate enlarged negative stage. As an enlarged negative is used, retouching becomes quite an easy exercise as relatively coarse work will hardly show.

Finally, the main advantage lies in the process of selection. Only the best negatives or slides need to be chosen. This selection procedure is very important, due to the range of corrective technique open to the sunprinter. The normal photographic restrictions necessary in conventional photography no longer apply. Almost any image could, with careful control of corrective technique, become perfectly usable. So a shift of emphasis from what is printable to why should it be printed, takes place. There is a great difference between beautiful rubbish and rubbish that is beautiful.

When working from conventional negatives, a positive is first made by contact printing from the original negative and this positive is then placed in the enlarger to give the *enlarged negative*. This positive should be of low contrast in the first instance, as contrast is easily raised during the duplication process, but is difficult to lower. The contact printing frame must be kept free of dust, grease smears and other debris. A puffer brush (or compressed air can), glass cleansing spray and antistatic cloth prove to be invaluable aids in the fight against the great enemies, dirt and dust. The low-contrast positive is now printed onto film or paper, and sometimes via a texture screen or half-tone screen, dependent on the required result. The density and contrast of this enlarged negative are controlled, with the characteristics of the final sunprinting in mind—any blue sensitive film is suitable for this process. Kodak safety positive or gravure positive flat film is also suitable. All these materials can be used under red or amber safelights, allowing development by inspection.

Where considerable tonal control is necessary, a better method is to project the original negative up to the size of the final sunprint, and produce an *enlarged positive*. Printing, dodging and shading can be accomplished in the same manner as in conventional projection print-

14

ing. Also, extensive retouching on this enlarged positive is possible. The enlarged positive is then contact printed to produce the final duplicate negative. Of course, further shading and dodging is possible during this second step. This is the most costly method as it involves two final-size sheets of film (intermediate positive and enlarged negative). One less expensive method is to go directly from the original negative to an enlarged negative by using reversal processing—dodging etc. can be used during the enlarging exposure. Another inexpensive method is to use a paper positive, as described in Chapter 2.

Coloured originals Colour negatives are treated in a similar way to monochrome negatives, except that it is best to use panchromatic film when making the positive.

Colour slides present a separate problem. It is a simple matter to project the slide onto panchromatic film or paper to produce an enlarged negative, but colour slides are much more contrasty compared with negative materials. Luckily a contrasty negative tends to work well with most of the sunprinting processes. The contrast range of a colour slide is reduced by either unsharp masking, an efficient but somewhat complex process, or careful tonal correction during the projection printing stage. This latter process is an extension of the normal shading and dodging practices used when enlarging.

Cheaper methods A cheap, effective method of producing useful negatives is to first print the original negative onto resin coated paper, then to strip it and make it transluscent using the technique described under the heading *Paper Negatives* in Chapter 2. This translucent positive is then printed by contact onto a material such as Kodatrace or lightly ground glass coated with a mixture of photopake, ammonium bichromate and gum arabic, using the gum-bichro method of sunprinting as described in the relevant section. This method is economical because the Kodatrace or glass are reusable, so the cost is only that of a sheet of resin coated paper and some gum mucilage.

Film is the best photographic material to be used in the production of enlarged negatives. Unfortunately, this is very expensive, but the cost may be reduced if slightly outdated film can be bought. This film, although not perfect, is comparatively cheap to purchase and is usually quite satisfactory. Check photographic magazines for the names of possible suppliers. This material is invariably of the line or process type and is not ultra contrasty like the lith materials, but still contrasty. The contrast is controlled by using different developers. For comparatively soft results developers such as D23 or Kodak Soft Graduation Developer should be used. Medium contrast is attained by the use of a normal negative developer such as IDII and very high contrast is easily obtained by using a lith type developer.

Paper negatives are very economical to produce. The only problem

is one of opacity. A paper base can absorb up to twenty times the light of that of a comparative film base. If the base is waxed or oiled this absorption is reduced, but not eliminated. Thin base papers such as airmail or document paper work best of all.

Contact printing frames come in a variety of shapes and sizes, some more efficient than others. The classical design, as illustrated, works reasonably well as long as there are strong springs on the back and a latex foam insert is used. Small size contact printing frames are sometimes found in junk shops and are usually quite cheap to purchase. The larger size frame, however, is seldom seen or found.

Large scale contact printing The large size contact printing frame is a fairly specialist item and may be difficult to obtain. Kodak market an excellent frame, 28 × 36cm (11 × 14in), which has the added advantage of an integral punch register system if used with the Kodak register punch. This is, however, rather expensive. Many suppliers to the printing industry market a range of frames of differing sizes which are very well made and should give years of service.

As most of the commercial frames are expensive to purchase, it makes sense to construct your own. This can be done very economically and design features are easily incorporated which give increased efficiency in operation.

The main design problem when constructing a contact printing frame is to ensure adequate contact of the negative and material to be printed on. If adequate contact is not maintained, fuzzy, out of focus areas and spots will result. An overall loss of sharpness will also occur, which can sometimes go undetected by the sunprinter, who may blame the negative instead of a faulty contact frame.

The secret of successful contact printing depends on pressure, which has to be even and strong. Most frames with a spring back do not give sufficient evenness or strength of pressure. Only when the spring is large can sufficient pressure be exerted.

As pressure increases, other problems arise. The frame must be made very sturdily otherwise the pressure can, over a period of time, split the corners of the frame. In addition, too much pressure can break the glass. Where heavy pressure is applied it is recommended that plate glass is used in the frame; the larger the frame, the thicker the glass needed.

As the size of the print increases, the greater the amount of pressure necessary if adequate contact is to be maintained. Latex foam inserts help to produce an even pressure across the frame. A frame design which works well up to a size of 40 × 50cm (16 × 20in) is illustrated. For larger sizes it is better to use a vacuum frame, which is a highly efficient method of contact printing.

Vacuum printing is employed to a great extent in the printing and reprographic industry. The vacuum frame usually consists of a glass-

topped light box containing lamps of high ultra-violet emmission. The negative and print material are positioned on the glass, then a frame, with a rubber sheet attached, is lowered onto the work. This frame is clamped tight, then all the air is evacuated between the rubber backing of the frame and the glass top of the light box by means of a vacuum pump. The effect of this evacuation is to sandwich the negative and print together, the atmosphere itself supplying the pressure. This method is highly efficient and accurate but the apparatus is very expensive.

An alternative method which is used occasionally in the silk-screen industry is the plastic vacuum bag, which is surprisingly cheap and is able to print very large areas. The more inventive sunprinter may be able to construct a plastic vacuum frame using thick polythene sheeting and a vacuum cleaner. Always remember that necessity is the mother of invention and home-made equipment, which sometimes looks rough and ready, can be very efficient in operation.

Frameless Contact Printing A simple and effective method of frameless contact printing was discovered almost accidentally by the author whilst undertaking experimental work associated with the development of the translucent paper negative method.

It is absurdly simple in concept, but very efficient in operation. The negative or positive to be printed is sprayed with spray mount adhesive. It is then positioned on the print material and lightly squeezed into contact with a hard lino printing roller. After exposure, the negative or positive is stripped off the printed material and placed on a clean piece of acetate or an old discarded glossy print. The object of this procedure is to preserve and protect the tackiness of the surface for future printing.

Spray mount adhesive is a remarkable product and is manufactured by companies such as 3M. It is a clear, one surface adhesive which provides a strong bond on most materials, and allows for repositioning. It is this latter characteristic which makes it ideal for frameless contact printing. The adhesive does not become brittle with age but remains tacky. As some of the adhesive is transferred at each printing stage, it will be necessary to respray the negative or positive from time to time. The adhesive can be completely removed at any time by gently wiping the surface with a chamois leather soaked in methylated spirit. Great care should be taken during this operation as the surfaces of negatives and positives are easily scratched. The only disadvantage in the operation of this system lies in the tacky nature of the spray adhesive itself, which picks up dust and other aerial debris, so clean working conditions are essential.

Another advantage of this system, besides the obvious simplification of the process of contact printing, is that as no glass is needed, more blue and ultra-violet radiation will get to the print material for a given

exposure time. Glass acts as an efficient filter for this type of radiation.

Registration Another useful feature to be included in any contact printing set-up is some system of image registration, so that multiple printing can take place with a reasonable chance of success. As previously mentioned, the Kodak printing frame does incorporate a punch register system but is rather expensive. Again, the handy sunprinter should be able to prefabricate such a system using the humble office punch that punches two holes. The size of a standard office punch hole is exactly 7/32in (0.56 cm) so it is a comparatively easy task to use this to produce two holes with the aid of a piece of punched film or card to act as a guide to the location and position of the register pins. These pins are made out of the drill itself. The end of the drill is cut using a hacksaw. Two pieces are cut of approximately 6–12mm (¼–½ in) in length, then sunk into the holes already drilled so that they only protrude by the thickness of three pieces of normal base film. These register pins should not protrude too far and interfere with any vacuum system which may be used with this form of image registration. The pins are then glued into position. They can be fixed to the frame itself or on a separate piece of wood. So, for a small capital outlay and some simple metal work, a very efficient punch register system can be made, allowing precise registration in multiple printing.

Exposure estimation As exposure in sunprinting is quite often judged visually, some means of observing the progress of the printing-out must be resorted to. In the conventional frame this is achieved by the use of a split frame back, so that while half the back is firmly held in the frame, the other half of the back is easily opened and the image inspected. It is slightly more difficult to achieve this inspection when employing a vacuum system, but with an efficient method of punch registration worked in conjunction with the vacuum printing frame, no trouble with misregistration should occur.

A few of the sunprinting processes do not respond sufficiently to give a visual image which is of practical use as a guide to correct exposure. In these cases an *actinometer* is a useful means to attaining correct exposure.

Actinometers vary in design and have been obsolete as far as photographic usage goes for a great many years, but they are easily constructed. First, a small contact printing frame is purchased or made. The glass in this frame is then covered with opaque tape so that only a strip of clear glass remains, as illustrated in fig. 00. Ten pieces of tracing paper are then cut up so that they slightly overlap the clear glass strip. The first piece of tracing paper is stuck down onto the glass strip, allowing just a small portion (x cm) of glass at the top of the strip to remain clear. The next strip is now stuck down on top of the first, but allowing 2x cm to remain uncovered by this second piece, the third

18

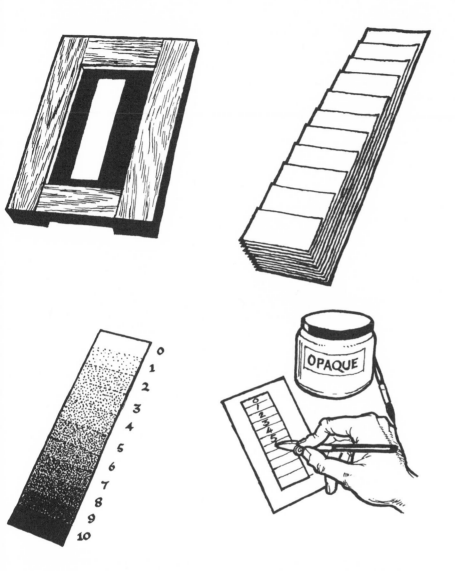

piece covers all but 3x cm, and so on. This procedure is repeated until all the tracing paper is stuck down, and a series of strips shows through the unmasked clear glass area, similar to a conventional step wedge used for sensitometric purposes. These steps of increased tracing paper density are numbers 0 for clear glass up to 10 for the greatest density (10 layers) of tracing paper. This numbering should be done with photopake used in a ruling pen. A fairly thick mixture should be used as the letters must be opaque. Pressure adhesive numbers will do as well.

The actinometer is loaded with a piece of fixed-out photographic paper, sensitized with a standard spirit sensitizer consisting of one part 10% solution of ammonium bichromate and two parts methylated

spirits. The photographic paper must always be kept the same, same manufacturer, same paper surface, and the same base material, all in the aid of consistency of operation in the actinometer. Cheap paper is quite good enough as long as a large amount is purchased. The paper will need to be fixed in a 20% plain hypo fixing bath and thoroughly washed and dried. The sensitization of this fixed-out photographic paper must take place immediately before use in the actinometer. To sensitize, the paper is swabbed by buckle brush with the spirit sensitizer on the emulsion side until no change in colour takes place. Then all surplus sensitizer is squeezed off the front and back of the paper so that it is just damp dry. In this condition it should dry in five to ten minutes in a stream of hot air. When dry, the sensitized paper is placed into the actinometer, sensitized surface face down onto the tracing paper. The split back is sprung into position. A large frame containing the negative

20

and coated base material is then placed in direct sunlight and given fifteen seconds exposure with the actinometer frame adjacent. Both frames are then removed from the direct sunlight. The actinometer frame is opened and the number which just shows or stands out against a pale tone is marked with the time of exposure, using an indelible pencil. The frames are then returned to the direct sunlight and a portion of the large frame masked with opaque material and then given a further fifteen seconds exposure and removed in the same way as before. This time a higher number should have become just visible. This higher number then receives its exposure time i.e. (15 + 15 = 30 sec). Using the indelible pencil, this procedure is repeated. Each time the large frame is further masked as for making a test strip in conventional photographic projection printing. A series of exposures having been made, the large sunprint is processed and dried. The actinometer is also processed in plain water until all the bichromate is dissolved out of the emulsion layer and dried. The two prints are now assessed for correct exposure. The strip on the large print which looks about right is directly compared with the actinometer strip, where the correct exposure should have a number printed out on the actinometer strip set against the correct exposure time written in indelible pencil. This number now becomes the exposure index for negative and print material, providing, of course, that the light sensitive coating is kept constant. This number is now carefully noted on the negative bag and on the rebate of the negative. All future printings are governed by this actinometer number. When it just shows up against the lightest tone, the exposure is complete and should be quickly terminated.

The beauty of this device is that it takes into account variations in daylight and will always give the correct estimation of the time of exposure, independent of the fluctuations in illumination, effectively solving one of the main problems in daylight printing.

Large scale contact printing is of major importance to sunprinting and, once the various technical problems have been solved, the operation of this kind of photographic printing is very fast and efficient. A great number of prints can be exposed at the same time. Up to twenty frames are easily manageable by an experienced sunprinter. This multiframe printing is a great experience, as a great pile of prints quickly appears. The main problem is keeping up with the coating, so that sufficient material is ready for the next batch waiting to be printed.

Basic chemistry The chemistry in this book has been so calculated that one single basic unit of measure is employed throughout, that is a level 5ml spoon (approximately a teaspoon). Both dry and liquid chemicals are measured in this way. This unit is quite accurate enough for the various sunprinting processes described in this book. A great deal of latitude exists in most of these processes.

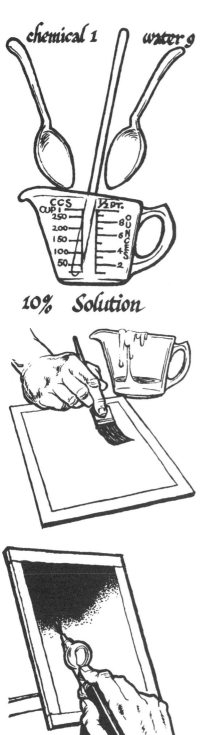

chemical 1 water 9

10% Solution

The use of this simple unit of measure makes the mixing of chemicals as easy as normal domestic cooking. There are no complex weights and measures to worry about. Most of the liquids are made up into 10% solutions, which are easily compounded by mixing one measure of dry chemical to nine measures of water. This is not a strictly accurate 10% solution but is adequate for use in creative sunprinting. Where solutions are to be kept for a considerable time or where they are photosensitizing solutions, the recommended solvent is, in all cases, *distilled* water.

Other useful equipment is a 1 litre pyrex measuring jug, a stirring rod of plastic or glass, and numerous storage bottles, clear and coloured. The coloured bottles are needed for light sensitive solutions or chemicals.

Care must be taken when dealing with some of the chemicals used in sunprinting, as they are mildly toxic if they get into the bloodstream. The bichromates, metallic silver, uranium and the ferricyanides are the main chemicals to be handled with care, but if common sense is used then no serious problems should occur.

All normal photographic chemicals will be needed, such as developers, fixers (plain and acid hardening), reducers, intensifiers and wetting agents. Wherever possible, it is best to keep these chemicals in a purely liquid form for easy use.

Coating procedure varies according to the nature of the sunprinting process used. Some can be coated in a number of different ways, whereas others are coated with only a single process.

Paint-on coating The coatings are easily brushed on using a normal domestic paint brush. To reduce the marks left by the brush hairs in the coating only the best quality brushes should be used, for example, a camel hair brush. The *Blanchard* brush which consists of a length of calico or flannel wrapped around a sheet of glass and secured with an elastic band or strong thread, is very useful. The *Buckle*, a similar brush developed during the early days of photography, employs a glass or plastic tube and a tuft of cotton wool partially drawn into the tube by the use of a length of thread or nylon fishing line as illustrated in fig. 00. Special brushes shaped like a stag's foot are used in the oil printing process. Their main function is the application of a greasy ink onto a surface of bichromated gelatine. The action of this type of brush is stencil-like.

Spray-on coating Coatings applied with a spray gun vary according to the gun's mechanical operation. An electric paint spray gives a fairly coarse coating. A small airbrush, such as the Airograph, gives a very fine coating. The spray guns used for model aeroplane spraying provide an intermediate spray coating.

Float-on coating Some binders require a very even method of coating,

gelatin being the principal one. Gelatin is, by its very nature, a strange substance to coat as it has two stages of drying. First it sets in the same way as a dessert jelly, then it slowly dries to a hard horn-like condition. So, it exists in three separate sheets – liquid, semi-solid (i.e. set in a jelly state), and solid. This triple-stage condition is what makes gelatin an ideal binder for conventional photographic emulsions, but it does make coating rather difficult. The best way to coat gelatin is to float it onto the base. This can be done in a number of ways.

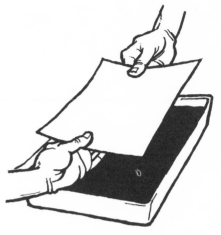

First, the paper base can literally be floated on top of a dish containing hot gelatin, or the gelatin can be flowed across the surface. Another alternative is to dip the material into the gelatin and slowly retrieve it. A sophisticated method giving very even coating is to spin the material and let centrifugal force even out the coating. Fuller coating details are included in Chapter 3.

Floating is an efficient method of coating for some of the metallic sunprinting processes.

Roll-on coating A very useful technique for coating is to use a domestic latex foam paint roller to roll the coating onto the base material. The author has pioneered the utilization of this piece of coating equipment for the gum-bichro process and the oil printing process. A foam roller is a very versatile coating aid. Differing textures can easily be attained in the final coating, from almost no texture to a very coarse one. The nature of the coating texture is dependent on the length of time the roller is used. The longer the rolling, the finer the texture. The amount of water in the coating mixture also affects the texture. The greater the water content, the stronger the texture.

Hard rollers such as those used in lino and litho printing have limited use as coating rollers. If these are employed, a tough base material will be needed, otherwise mechanical damage is bound to occur. Occasionally, however, they are very effective in texture screen production and collotype printing.

Base preparation Most sunprinting processes require some form of base preparation, otherwise the light sensitive coating would, in most cases, sink into the fibres of the base material and never appear again. Therefore, *sizing* is an essential feature of this type of print-making.

The sizes which are frequently resorted to either act as an insoluble layer or become soluble at a later stage in the processing cycle. Most of the sizes which were in use in earlier times were soluble in character, such as glue, gelatin, arrowroot and starch, but most modern sizes are insoluble, P.V.A. medium being an excellent case in point. Also, acrylic varnishes work well. Sometimes the size contains some of the chemistry of the process as in the metallic sunprinting processes. In this case it is best if the size remains in a soluble or semisoluble state. The insoluble sizes are best employed in the bichromated colloid processes such as

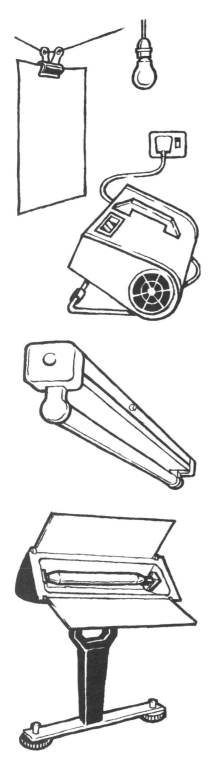

gum-bichro, oil and carbon. In the dye processes also an insoluble base is preferable, as a protection against the dye.

Drying Great care must be taken during the drying process, first to guard against airborn dust and secondly not to overheat the various sunprinting coatings. Apart from the platinotype, all sunprinting coatings are easily fogged by excessive heat. Whenever possible use convected warm air to dry, instead of radiant heat. A hairdryer or fan heater is ideal. Platinotype, on the other hand, needs plenty of heat and works best in bone dry conditions.

Light sources The assessment of the relevant merits of light sources suitable for sunprinting is a fairly complex matter.

Intensity, cost, strength in terms of actinic light, consistency, evenness, maximum area of illumination and problems of heat emission — all these have to be taken into consideration. There is no light source which is optimum in all respects, but direct sunlight fulfils most of the conditions for an ideal light source.

As a source of light, sunlight has much to recommend it, being of very high intensity, cheap, highly actinic, extremely even and covering an almost infinite area of illumination. The main disadvantage for some locations is, of course, erratic weather conditions. The careful use of an actinometer helps to counteract this inconsistency, but if dark, dull lighting conditions prevail, sunprinting can become impractical and another source of light has to be found. There are few artificial light sources which compare favourably with direct sunlight. Most are weak in intensity, have a limited area of illumination and are expensive to purchase. They also require the additional purchase of replacement lamps from time to time. But there are occasions when an artificial source of light, however imperfect, is essential to allow print-making to continue.

Photoflood bulbs, studio lamps of high wattage, sunguns (i.e. tungsten halogen), high intensity, ultra-violet, mercury vapour lamps and fluorescent tubes, all work reasonably efficiently. Photofloods, studio lamps and sunguns emit a very high proportion of radiant heat which, if care is not taken, can cause heat fogging and even distortion of the negative film and paper base material.

Mercury vapour illuminants on the other hand are comparatively cool working, as they emit atomic light rather than hot incandescent illumination. Unfortunately, they are weaker in action than the comparable tungsten lights, resulting in long exposure times. The high intensity mercury vapour lamp is an exception to this rule, but is expensive to purchase and complex to set up. It is used extensively in the reprographic and printing industry as a high intensity illuminant.

The sungun has a very high light output, almost as strong as direct sunlight, which makes it suitable as an alternative to sunlight. Unfor-

24

tunately, it also has an extremely high radiant heat emission which can cause trouble, but if a fan is used to cool the contact frame during exposure some of the problems caused by overheating are alleviated. A way to make the most of tungsten halogen illumination, and at the same time keep it comparatively cool, is to take advantage of the cooling system which is an integral part of most modern colour slide projectors and work the projector as a light source. Because of the amount of glass contained in a conventional projector, a large proportion of the ultra-violet radiation is absorbed.

This absorption reduces the effective intensity of the tungsten halogen light source but if pressed into service with care and efficiency it will still provide sufficient intensity of actinic light for reasonable exposure times.

The nature of the light source seriously affects the tonal reproduction of the resultant sunprint. A broad source of illumination such as diffuse daylight, blue skylight or mercury vapour fluorescent tubing gives a very soft graduation of microtone. A point source on the other hand such as clear direct sunlight or the tungsten halogen light, gives harder tonal contrast. Both types of illumination can, on occasion, be used to help in the creative exploitation of tonality. Broad source microtonality gives smooth soft tonality suitable in child portraiture. Point source illumination and the resultant microtonality supplies the converse image quality, providing sharp clear tonality of a more brutal nature, highly effective in, say, dramatic landscape photography. So both types of microtonality are of importance to the creative sunprinter in the extension and mastery of creative sunprinting.

Whenever possible, natural daylight should be utilized. Pure clear sunlight has a strong aesthetic quality. Most people love sunlight which quite often gives them an emotional charge of sheer pleasure. A double pleasure is the reward for the creative sunprinter – beautiful sunshine coupled with enthralling print-making.

2. Creative Control Of Tonality

Continuous tone To fully appreciate creative photography is to have a deep understanding of tonality. A conventional photograph is in essence no more nor less than a series of grey or coloured areas which gradually progress from black through to white. To make this progression come to life and vibrate with dynamic energy requires sensitive observation and careful, skilled photographic recording. The visual tension of one tone to the next must be felt on an intensely emotional level.

Tonality controls not only the mood of a picture but also, to a large extent, its meaning. Light pearly tones impart a light emotional feel in the image, for instance, the literary term 'light hearted' could be illustrated in pictorial form by the use of light tones in a high key manner. High key is a term used to describe a print where all the tones are in the upper register, pure white, very light greys, no middle tones and small areas of dark shadow tone. The overall effect of the print should be one of luminosity, full of light and softness. Conversely, the term 'dark forces at work' immediately conjures up the opposite, dark mysterious tones of a low key print. These are exaggerated examples but tonality is quite often a very subtle thing with an elusive quality difficult to put into words. One has only to look at some of the past and present masters of photographic tonality to see how the tones of their photographs speak in a fluent visual tongue.

The soft platinotype prints of cathedral interiors by Frederick Evans display soft, quite grey tones. These convey a haunting quality, exquisitely seen and recorded. The dark, 'wet' quality of Edward Weston's studies again demonstrate the possibilities inherent in a full range of tones. The soft sensual tones of David Hamilton's photographs of young girls, mirror the mildly erotic nature of his work and can be dramatically contrasted to the harsh tonal prints of photojournalists such as Don McCullin who specializes in photographs of war, mayhem and civil unrest — the harsh tones precisely match his picture content.

All of these great photographers use the tonal range of their prints to express a personal form of visual communication. The creative sunprinter must endeavour to develop a sincere personal style in the same way that these great exponents of tonality evolved theirs. To sharpen up tonal awareness the creative sunprinter is well advised to undertake a series of exercises devised to increase his sensitivity to subtle tone variations.

The subject matter of a photograph tends to mask the effects of tonality, therefore, if subject matter is removed, tonal relationships can be closely studied. So, without the use of a negative, make a series of stepped exposures onto a piece of photographic paper using conventional photographic technique. Use arithmetic and geometric sequences i.e. (2+2+2+2+ and 2+2+4+8+ etc). Observe carefully the light, middle and finally the dark shadow tones. Repeat this experiment on differing grades of paper contrast. Compare and compare again, try to feel the emotional tension between the tones. These results can later be related to real photographic images.

Ansel Adams, the famous American landscape photographer, considered that the understanding of photographic tonality was so important, he invented an elegant system of tonal control known as the *zone system*. This system is in many ways similar to musical notation. The system has disciples throughout the world. However, a systematic approach to creative photography can become a kind of brainwashing. Individual exploration towards personal understanding is preferable. Photography lends itself too easily to imitative work which is generally a pale copy of the work of a great photographer. The student should look within him or herself for personal inspiration. There is a vast amount of unexpected creative wealth and information just waiting for discovery.

Contrast control One of the principal controls of tonality is contrast. It is a crucial characteristic. Slight changes in contrast seriously affect the final quality in a strongly subjective way. This causes problems when undertaking sunprinting as different photosensitive processes have inherently differing contrast criteria, making precise control difficult to achieve. The processes can either be manipulated to match up to a standard negative, or the negative can be especially made for each process. For example, if you have an inherently low contrast process, a high contrast negative is made to balance the process. Both of these procedures cause problems. In the first, manipulation of all the sunprinting processes is not always possible. In the second a number of negatives from the same original negative have to be made if a range of sunprinting processes are going to be used. A third method which nearly solves all these problems is to consider the use of the half-tone principle instead of continuous tone, or if not half-tone then texture tone or collotype.

Half-tone process This process is a method of converting a continuous tone original photograph into a series of black and white dots of varying size—these dots giving the appearance of tonality. The half-tone principle relies on the fact that the eye suffers from a limited acuity. If a series of dots are small enough the eye cannot resolve them and they appear as a continuous tone. In other words, the dots are blended together to give a tonal average. A low powered magnifier used on a newspaper reproduction demonstrates this principle. Highlight areas are represented by large areas of white with a few small black dots present. Shadow areas are pure black or hold a few small dots of pure white. The middle tones show up as a checkerboard of black and white squares of roughly equal size.

The credit for the idea of breaking up the image into dots by means of a network screen is due to William Henry Fox Talbot, the British inventor of silver halide photography. He proposed the use of crepe or gauze to achieve this end in a patent of 1852. He also suggested the use of a glass plate ruled in fine opaque lines. However, it was not until 1893, when Max Levy of Philadelphia patented his process of etching lines into glass and filling them in with black pigment, that the process became a commercial success.

The *Levy screen* consisted of parallel lines ruled diagonally on two glasses, which were then sealed together face to face with Canada balsam, thus forming a network of crossed lines. This screen was then used in a photochemical process copying camera where it was positioned in front of the sensitive material so that it was just out of focus. This lack of focus was essential to produce an even tone structure in the final half-tone image. The sensitive material used for half-tone work must be of extremely high contrast so that the final half-tone image is made up of practically opaque density on clear film.

The Levy screen was very expensive to manufacture and difficult to work. This led to the introduction of a much cheaper and easier method known as the *Kodak Magenta Contact Screen*. As the name implies, the Kodak screen is held in contact with the light sensitive material during photography. A still simpler system is a material marketed by Kodak known as *autoscreen*. When this is used no screen is required. The only disadvantage with this process, apart from the cost, is that it only comes in a single ruling of 52 lines per cm (133 lines per in) which is slightly coarse for high quality work.

Screens come in varying degrees of line ruling—that is the number of lines to a cm (or in)—from 20 lines per cm (50 lines per in) for coarse work, up to 150 lines per cm (400 lines per in) when used for high quality fine work. The more lines per cm, the more difficult the technique is to operate, but on the other hand, the smoother the tones, the greater the fine detail which can be resolved, adding heightened image quality.

The half-tone negative offers considerable advantages to the creative

sunprinter once it has been made. It is a simple operation for the average photographer, and there are lithographic and screen printers who are prepared to make these negatives from continuous tone prints for a small charge. As the negative is made up of pure opaque density and clear film, the exposure for one halftone negative is much the same as for the next. Also, a great deal of latitude of exposure is possible. Both these factors help in simplifying the sunprinting procedure.

Multiple printing using half-tone negatives sometimes suffers from a fault known as *moiré* patterning, an effect caused by the interference of one pattern or network with the next. These patterns can be observed if two pieces of net curtaining are positioned in relationship to each other. This optical effect can be very attractive in its own right, but normally it it just a nuisance. The effect can be minimized at the negative production stage by rotating the screen through an angle of 16° for each successive negative.

Texture-tone screens The half-tone screen is geometric in construction. If it were random in construction, moiré patterning would not occur. Texture-tone screens offer an exciting alternative to the half-tone principle, being random by nature of their construction. In addition, they can be individual in visual effect, allowing the sunprinter an even greater freedom of expression.

The painter Georges Seurat produced some great masterpieces and many remarkable drawings using a *pointilliste* style (using dots or stippling). He broke his images up into small dots using graphite in his drawings and a system of rainbow colours for his paintings. He juxtapositioned a mixture of red, green, blue, orange, violet and yellow dots to produce any shade of colour. As a method of painting this gave a very dramatic and exciting vibration of colour.

The texture-tone techniques can provide similar optical effects. The texture of the tone can be relatively coarse, making the vibratory effect strong and energetic, or being smooth, the texture could hardly show. Where coarse texture is required the screen is best positioned next to a positive at the enlargement stage. When the positive is enlarged to produce a negative suitable for contact sunprinting, the grain of the texture screen will also become enlarged. Fine texture needs the reverse action. The texture-tone screen should be positioned in contact with the sensitive material which is to be made into an enlarged negative and the positive projected through this sandwich.

The production of a texture screen is a fairly simple exercise. It is useful to gradually increase contrast at each stage in the production of a texture-tone negative, therefore, the screen should be *fairly* contrasty. A film stock of the line variety developed in dilute print developer is about right.

A fine screen can be produced by contact printing paper onto film which will give textures from fine and gritty to coarse and woolly. The

thinner the paper, the finer and tighter the texture. Airmail photographic paper which has been fixed out produces a very fine texture, whereas blotting paper has a coarse, woolly texture.

Semi-translucent materials are extremely useful in producing fine texture. Ground glass, Kodatrace, decorative glass and repeated application of fixative spray on a sheet of glass all provide screens in a variety of fine textures.

One of the finest of all textures is the aquatint used to provide tone in autographic printing. This is a very fine texture produced either by dusting a surface with bitumastic dust or using a reticulated liquid ground, made up of resin dissolved in alcohol.

For the dusting method of aquatinting a dust box is used. Asphaltum dust is placed in the box which is then agitated, or a blower is inserted into the box to disturb the dust. A suitable support is then inserted, such as a sheet of glass, and the dust falling onto the sheet makes the texture. The longer the time between insertion of the plate and the agitation of the dust, the finer the grain or texture. Once the glass has been dusted, it should be slowly heated to make the dust tacky to firmly attach it to the glass.

The second method is to coat the resin and alcohol mixture onto a suitable support. As the alcohol evaporates the resin reticulates into a granular pattern. The proportion of alcohol used determines the coarseness of the screen.

Photographic graininess is also a useful source of texture and can vary from very fine to coarse according to the method of production. Development must be as even as possible to ensure evenness of tone in the resultant negative.

Decorative textures will give unusual results and provide a rich storehouse of creative imagery for the enterprising sunprinter. Photographs of natural textures such as sand, rock, wood, grain, leaves, grass, tree barks, and dozens of other naturally occurring textures can be pressed into use. Professor Otto Croy's excellent book entitled *Photographic Design* published by Focal Press, is illustrated with many imaginative examples of graphic texture.

A simple method of texture screen production is to take a piece of Kodatrace, or a sheet of ground glass, and roll some lithographic ink onto a slab of glass with a hard lino printing roller. Then take a latex foam decorating roller and roll it a couple of times over the ink-laden glass slab. The object is to take up a small amount of ink onto the roller. Now gently roll over the Kodatrace. Keep rolling backwards and forwards until a thin, even coating of ink forms on the surface of the Kodatrace. Then hang up the Kodatrace to dry in a warm, clean atmosphere. The resultant screen must be left for 24 hours to thoroughly dry and finally sprayed with fixative.

Collotype There is a slightly more complex method by which a texture

tone result can be achieved without the use of a screen, based on the collotype process, using an image in lithographic ink. The image made by this process is very sharp with fine tonal definition, well worth the extra effort required to make it. The image mechanism works on the principle that if a film of thick bichromated gelatin is exposed to sunlight under a negative or positive, it will become differentially hardened and take up ink in direct proportion to the light action. This method has survived as a form of quality printing since the early days of photo-mechanical print-making and is still used for high fidelity facsimile reproduction. The process is similar to oil, bromoil and the lithographic processes, working on the basis of the mutual repulsion of oil and water. Apart from the Woodbury type printing process, now obsolete, collotype is the only printing process which does not require the use of a half-tone negative or positive to give the effect of continuous tone.

Collotype gives a smooth tone with a fine texture visible only through a high power magnifier. As this process is negative/positive in character, a continuous tone positive will be needed to produce a collotype texture tone negative suitable for further sunprinting.

The classic process can be used, that is, a piece of plate glass is ground and coated with a layer of bichromated gelatin in a similar manner to the production of a carbon tissue (fully described in Chapter 3). This emulsion is exposed to a continuous tone positive using normal sunprinting technique. Exposure is judged by test strip or by the use of the actinometer. After exposure, the collotype matrix, or cliché, is developed in cold water, and left in the water bath until the yellow-orange colour of the bichromate is fully discharged. This soaking is continued until the more heavily exposed regions change from a warm brown to a slightly greenish-grey colour. The matrix is dried in a stream of warm air, care being taken not to overheat it. When dry, the matrix can be stored for later printing or conditioned immediately. Conditioning takes the form of immersing in a bath containing 40% glycerine, 50% water and 10% ammonia. The matrix is left in this conditioning bath for twenty to thirty minutes. Remove all surplus conditioner by squeegeeing it gently off the surface. This is completed with the aid of a chamois leather. The matrix is now inked up using a hard lino printing roller charged with stiff black lithographic ink. At first the ink will stick uniformly all over the matrix, but as the roller moves backwards and forwards across the surface of the matrix an image will begin to appear. When this stage is reached, dampen the matrix with the chamois leather, moistened with conditioner. Do not oversoak. The matrix must only be dampened, not flooded. A latex foam roller is now employed to bring the image into a bright clean condition. This final stage requires some practice.

Once the image has been pigmented it should be left to dry. The gelatin dries fairly rapidly, but the ink will take a considerable time to dry properly, at least 24 hours. The matrix is best left in a warm

dust-free atmosphere for two or three days and then, when the ink image is dry to the touch, sprayed with artists' fixative, left for an hour and sprayed again. The image should now be completely permanent and smudge-proof.

The task of matrix preparation can, at times, prove difficult to work, but there is an alternative which works just as well and offers considerable advantages. The collotype effect relies on a controlled *reticulation* of the gelatin surface caused by the expansion and contraction of the gelatin fixed to a dimensionally stable base material, namely glass. This relationship between an unstable substance, such as gelatin, and a stable substance, such as glass, causes the gelatin to crack and split into a characteristic pattern known as reticulation. Most modern flat films now use polyester materials as base materials, for example, Kodak's support is called Estar. These bases are comparatively stable and, therefore, provide a material suitable for matrix production. The use of a readily coated material saves a considerable amount of time and a simplification of the process.

First, a piece of film on a polyester base is fixed out in a 10% plain hypo bath. The film is now washed, rinsed in wetting agent, sponged or squeegeed damp dry and dried in a stream of warm air. Great care must be taken at this drying stage, as any unevenness of drying will print later on.

Once dry, the film is sensitized in a standard spirit sensitizer, as used in the carbon process, consisting of two parts methylated spirit and one part 10% ammonium bichromate solution. When sensitization is complete—usually from one to two minutes—the tissue is placed, face down, on a clean sheet of glass and the back is lightly squeegeed to remove all the excess sensitizer.

The film is now turned over and the surface is very gently wiped with a piece of chamois leather or latex foam. Great care must be taken not to damage the film surface which is extremely tender at this stage and any scratches will print later on. The sensitized film is now dried in a stream of warm air, preferably in total darkness, as the emulsion is now light sensitive. From this stage, the sensitized flat film is treated in exactly the same way as the classic plate glass matrix. This method has similarities to the oil transfer process, but generally produces results of far higher quality. Unfortunately, the main disadvantage is the very high cost of the matrix material.

Paper negatives Some of the first negatives ever made were produced on paper by the English inventor and country gentleman, William Henry Fox-Talbot, who pioneered silver halide photography. The *calotype process* as it was called showed a distinct grain or texture in the final print. This was a disadvantage of the process at the time, compared to the sharply defined and grainless results of the *Daguerreotype process*, the principal rival to Fox-Talbot's method of photography.

Despite this disadvantage and even because of it, these early calotypes exhibited a charm and a simple sensitive quality which still works well even in this more sophisticated age. The softness of definition caused by the paper grain admirably suited the needs of the photographic portraiture of the time. D. O. Hill and R. Adamson, two Scottish gentlemen, quickly established a reputation for portraiture in the classic style, specimens of which still survive today in various photographic collections. Many consider these portraits to be some of the finest examples of photographic portraiture ever made.

The paper negative has been in and out of favour as the pendulum of popular taste has swung from art photography to pure photography and back again. Apart from the basic graininess of the image, the front and back of the print offer endless opportunities for tonal correction or enhancement by retouching. Whole areas of subject matter are easily deleted or changed. The process offers unlimited freedom of tonal expression and subject control. It is understandable why proponents of pure photography are horrified at the mention of paper negative work as some of the efforts of the more banal workers were truly horrific. When bad photography and incompetent drawing combine, the result is often a disaster.

Optical and drawn images can live in perfect harmony as long as the intention of the work is honest and sincere. The work of Larry Rivers, Robert Raushenberg and Andy Warhol exhibits this marriage of images. Each component of their pictures is meant to convey a mood, an idea or a feeling. The work of these artists is acclaimed in the major galleries of the world.

This barrier between painting and photography seems to have broken down in one direction but not in another. It is perfectly acceptable for a painter or fine art printmaker to use photographic material as a basis for their work, but let a photographer pick up a pencil or paintbrush and the howls of dismay can be heard for miles. To be fair, it is generally the photographic fraternity who turn to savage their own colleagues. Most other artists are quite liberal in their attitudes. However, ideas are changing with more catholic teaching programmes in colleges. A new breed of photographer is emerging whose main interest is meaningful imagery, however produced.

Making paper negatives This process can consist of a simple single stage or become extremely complex and diverse in scope, where the image goes through a number of stages to reach the final result. The problem is where to start. This depends on how clearly the final result is previsualized. Once the destination is known, the journey is easily made.

In its most simple form a paper negative is made by contacting a positive print onto low-contrast photographic paper. A thin based paper such as document or airmail is best. The negative image is produced by

using standard photographic technique. A colour slide can be used instead of a print by projecting it onto photographic paper. As a colour transparency is by nature extremely contrasty, some local dodging may be necessary to reduce the effective density range. For results which are most true to the original scene, the transparency should be printed onto a panchromatic paper (e.g. Panalure) or an internegative using panchromatic film should be made. As previously stated, the original print and the resultant negative can be extensively retouched by the use of graphite which gives a very even tonality when carefully applied. As a general rule, the work on the front surface of the positive or negative will show sharply, but the work on the back will only show as a general lightening or darkening of tone.

The process of retouching and then printing can be repeated over and over again. Tonal detail is lost at each printing stage, only to be retouched back in by the use of pencil stump, knife and bleaching solution (usually *Farmer's reducer*.) This process rapidly turns the photographic image into a drawing. This is where great skill and a sensitive feel for the autographic image is required on the part of the photographer.

One of the prime advantages of the paper negative is the cost. A sheet of photographic paper, especially the thin based type used for the negative costs a fraction of the amount of an equivalent sheet of film. However, problems do arise through the use of paper, the main one being the opacity of the base which can absorb from 10 to 20 times the light that would have passed through an equivalent film base. This defect can be minimized to a certain extent by waxing or oiling the paper base. One method is to float the paper negative face up on a hot bath of wax, then remove, cool, and place between two pieces of blotting board. The print is then ironed with a hot iron or placed in a mounting press with the thermostat turned up high. The second method is to apply, with the aid of a brush, liquid paraffin to the back of the negative. Two coatings, an hour apart, are needed. A third way of producing a translucent finish to the paper base is to rub into the back of the print, with a pad of cotton wool, a solution of one part Canada balsam in five parts of pure spirits of turpentine. Do not use commercial white spirit substitute.

A further method that produces a grainless, translucent paper negative, relies on the use of photographic resin coated paper. This paper, as the name implies, is coated on each side with a manmade plastic. A layer of plastic is covered by the central paper fibres, on which there is another layer of plastic, coated with the photographic emulsion. If the back plastic surface and central paper fibre are removed, the photographic emulsion is only resting on a thin grainless layer of translucent plastic, with ideal characteristics for creative sunprinting.

The plastic layers in a resin coated print are easily separated by the use of a sharp knife, scalpel, or razor blade. The knife is placed at the

corner of the print and the two surfaces are gently teased and prised apart. When about an inch of the corner is separated in this manner, take a firm grip on both corner edges, one corner in each hand. Both surfaces can then be gently but firmly stripped apart. Sometimes damage does occur during this stripping operation, but this is rare.

A safer, slightly more complex method, is to prise the layers apart along the whole of one edge of the print. When this has been done, place the print on a flat surface and attach one edge to this surface with clear adhesive tape. Stick the second edge to a length of wooden dowel, approximately half an inch in diameter. Then roll the wooden dowel along the surface stripping the two layers apart, and when the two surfaces are successfully separated, the non-image surface is discarded. Spray a clean piece of glass with a spray mount adhesive and place the stripped print on this bed of adhesive, face down. Lightly roll it into contact with a hard lino printing roller. At this stage in the process there is still a considerable quantity of paper attached to the back of the negative print. This paper fibre must be carefully removed with a nail or hand brush. Dampen the paper fibre first with water then sprinkle with scouring powder. Start from the centre of the print and scrub in a circular fashion from the centre to the edges. The edges of the print are easily torn if care is not taken. It is a good idea to have at least a 1 cm (½ in) border allowed for in the original print production. Gently scrub, dampening and sprinkling the powder, until all the rough paper fibre is removed from the back of the print and the smooth plastic is revealed. Work with a firm but gentle pressure, remembering the plastic layer is thin and very fragile.

When all the paper fibre is removed, rinse off any surplus powder, using a stream of water and carefully dry the print, still attached to the glass by the layer of spray adhesive. Cover the back of the print with a layer of transparent book covering material, which is a clear, self-adhesive acetate. Then trim the border of the print by the use of a scalpel and steel straight edge and lift the grainless, translucent negative or print off the glass. The surface of the print is tacky to the touch. This is a useful quality as it can be used for frameless contact printing (see page 17). Alternatively, the adhesive can be removed by wiping the surface of the translucent negative with chamois leather soaked in methylated spirit. The cost of producing this type of negative or positive is at least a quarter of the normal film price and, in effect, means that a translucent negative costs only slightly more than a normal photographic print. The additional work required is more than rewarded by the simplicity of resin coated paper print production and the resultant savings.

Contact problems sometimes occur in paper negative manufacture, the main one being that the print will not lie flat. This defect is overcome by soaking the print in a 5% solution of glycerine and then drying it under pressure in a flat bed glazer, or by placing it in a dry mounting

press sandwiched between four blotting boards, two above and two below. Alternatively, this sandwich can be placed under a pile of heavy books and left overnight to dry.

The textural quality inherent in the paper negative/positive type of image is easily transferred into the standard transparent texture/tone negative or positive (see page 14) by contacting the paper negative or positive onto line film, developed in a print developer. The nature of the print material will control the type of texture/tone, also any autographic work undertaken on the print will leave its mark. Graphite texture and paper texture merge to form an amalgamated texture.

The paper negative offers an extremely useful technique, allowing a degree of personal freedom of almost unlimited scope.

3. Pigment Sunprinting Processes

GUM-BICHRO PIGMENT PROCESS

History The gum-bichromate process has become at times very popular, only to fade into obscurity until some new technical need, or change in popular taste, resurrects it again. The process was partially discovered by a Frenchman named Vauquelin during basic research into light sensitive compounds as far back as 1798. Mungo Pontin, a canny Scotsman, rediscovered it in 1839 and promoted it as a cheap alternative to Fox Talbot's calotype silver process. It was up to a French physicist, Edmond Bequerel, to establish the role of the colloid in the photographic reaction. He found that it was the paper size in combination with the chromic salt that caused sensitivity to light.

The bichromated colloid reaction was further investigated by the so-called father of the pigment processes, Alphonse Poitvin who published a series of inventions using a number of colloids of differing physical characteristics, gum arabic being one. He patented his results in 1855 and was rewarded for his brilliant research in June 1859, when he was credited with inventing a permanent photographic printing process and received the Duc de Luynes Prize in recognition of the part he played in this advance of photographic technique.

Forty years were to elapse before gumprinting again rose in popularity, this time under the mantle of an art photography movement. The process was introduced by Rouill-Ladeueze in 1894 and popularised a year later by Robert Demachy. The visual arts at this time were in great turmoil. The gum-bichromate revival arose from the challenge by leading photographers to the values of the photographic establishment. They joined fellow artists in the great secessionist movements of the latter half of the nineteenth century.

The gumprint has always invoked controversy as the process is the least photographic of all the historical pigment control processes. The image can easily be modified, tonal values changed, image detail

omitted and the structure of the surface marked by brushwork. The final result can be far removed from the original optical image produced by the camera.

A. Horsley Hinton, a famous Victorian pictorial photographer, defended the manipulative approach to picture making in the following statement: 'In the presence of a gum-bichromate print where there is an abundant evidence of brush development, one often hears it asked 'Why did not this man paint his picture at first hand?' The answer is quite simple, 'Because he could not.' There are men who possess a fine artistic perception and knowledge but entirely lack the manipulative skill with either pencil or brush. Photography relieves them of the need for the latter and the gum-bichromate process allows the full exploitation of the former.'

However, the photography establishment at the time went out of its way to ridicule the new movement. Terms such as 'paperstainers', 'precious daubs' and 'meretricious efforts' were hurled at the art photographer. Superficially some of these comments were justified. A great deal of the work was urbane, sentimental and plagiaristic, catering for the excesses of Victorian taste. However, the ballet dancers of Robert Demachy and the simple poetic landscapes of J. C. Warberg live on as valuable examples of the creative possibilities inherent in the gumprint process.

Photography at the time was still finding its way aesthetically. It was no more than a child emerging from the cradle, eager to experience life but not quite sure how to go about it, whereas painting and the graphic arts had been fully mature for centuries. A child is bound to imitate any adult in its vicinity without necessarily understanding the motivations of the adult.

Robert Demachy bravely defended the art photographer in *Camera Work*, an important Stieglitz publication. He pointed out that art is a creation of the artist himself. Art as such does not exist in nature or indeed outside the consciousness of the artist.

Recently the gum-bichromate process has once again made a return as a creative printing technique. This present revival has been partially instigated by a reaction against the policy of leading photographic manufacturers to restrict the range of surface base and emulsion characteristic of their print materials. A stronger reason for this renaissance could possibly be nostalgia, a reaction against increasing technology and its dehumanizing effects.

Gumprinting offers almost unlimited freedom of creative expression in print-making. The photographer becomes his own manufacturer of sensitive materials. He can cater for his personal needs in a way impossible when using the ready-manufactured product.

Colour photography is still to a large extent governed by objective criteria. If a major breakthrough is to be made in the promotion of subjective colour photography a more controllable and flexible

approach is needed. Colour is a field hardly touched by the gumprinter, yet the process has inherent qualities just waiting to be exploited by the inquiring sunprinter.

Basic process In theory a gumprint is very simple to make. Gum arabic solution is mixed with ammonium bichromate and powdered pigment to form a sticky mixture known as a *mucilage*. This is coated onto sized watercolour paper and thoroughly dried in a stream of warm air. Once dry the coated paper is printed in contact with a negative, by daylight, until the image detail can be clearly seen to have printed out. This image is then fully revealed by placing the print face down in a dish of plain water. The unexposed gum streams out of the print into solution leaving only the exposed image in hardened gum. The print is now made permanent in a 5% solution of acid hardener. This fixer is removed by a quick wash rinse and after drying the print is ready for finishing or further sunprinting.

In fact, each stage in the production of a gumprint must be very carefully controlled and constantly scrutinized or disaster will almost certainly result. The key to successful gumprint-making is to adopt a highly disciplined technical regime based on an accurate knowledge of the contribution made by each constituent of the gum processes in relation to the other constituents. The achievement of a correct chemical balance between all the materials used is absolutely essential if the full beauty and soft sensitive quality of this sunprinting method is to be attained.

Understanding the function of the materials which make up the mucilage is central to accurate control. Problems with the mucilage usually cause most trouble to the beginner. Three basic substances make up the mucilage, the colloid, the sensitizer and the colouring matter. The colloid has a dual function to perform. First it acts as a binder or medium for the colouring matter. Secondly it has the crucial function of becoming the light sensitive material itself. There are a number of materials which could be used as colloids, such as egg white and fish glue, but gum arabic has the right physical characteristics to make it perfect for use as a colloid. Gum arabic is a natural resin that is highly soluble in water, but when a chromic salt is added to the gum solution it becomes sensitive to exposure to daylight. The daylight makes the gum less and less soluble in water. This tanning or hardening of the colloid by exposure to daylight constitutes the basic image-making mechanism of the process.

The more sensitizer, usually potassium or ammonium bichromate, that is added to the solution the greater the sensitivity to light of the mucilage. There is, however, a practical limit to the amount of bichromate it is possible to dissolve into solution. Potassium bichromate becomes saturated at a 10% solution and ammonium bichromate at 20%. If solutions greater than these are used the chromic salt will, on

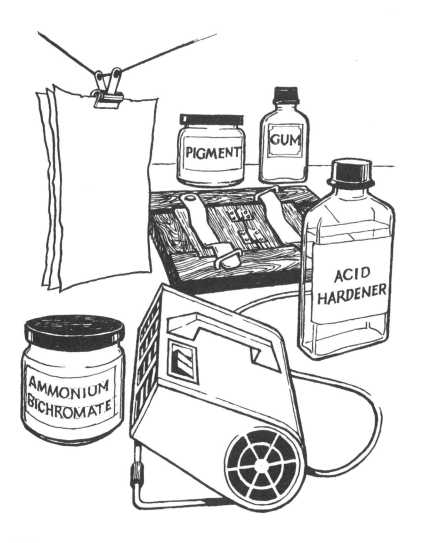

drying, crystallize out of the coating thereby ruining it for printing. Ammonium bichromate, because it allows greater saturation, is more sensitive than potassium bichromate, otherwise there is no difference between the two salts. It is not wise to exceed 15% solution of the ammonium bichromate to the total solution of the mucilage. The ratio of bichromate to mucilage solution also governs the final contrast of the print. Unfortunately it works in reverse to the sensitivity, the greater the bichromate concentration the lower the contrast. The contrast of a gumprint is usually very low, so a compromise between light sensitivity and contrast is inevitable. The gum bichromate emulsion is very insensitive to light. An accurate emulsion or film speed is almost impossible to determine but light sensitivity of the order of 0.003 ASA can be expected, this means an exposure to daylight of five to fifteen minutes.

The colouring matter provides body to the image formed in light-

hardened gum. This colouring matter nearly always consists of pigment, although in special circumstances dye stuffs can be used as an alternative to pigment. The pigment should be chemically inert, but unfortunately it is sometimes found that the pigment has an unfavourable side reaction on the mucilage. Obviously, when this occurs try an alternative pigment. Powder colour is recommended for this process, but poster, watercolour and gouache can on occasion be successfully used. Problems sometimes arise, however, from the additional gums and resins included in the tube colours. Small amounts of this type of colour will not in fact cause a lot of trouble, only large additions to the mucilage will cause any real malfunction. In any case, good quality watercolour is extremely expensive.

Always use the best artists' dry colour. Apart from chemical purity, this provides a rich highly saturated texture. Do not use the less pure and cheaper 'school' type colour which can upset the chemical balance of the mucilage.

Mucilage is a term which describes a very sticky semi-liquid that can be messy to handle, to say the least, so be warned.

The moisture content or wetness of the mucilage is critical, as very slight changes in the amount of water present will cause major changes

41

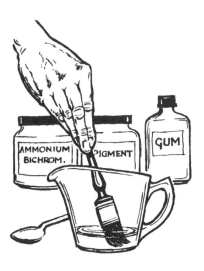

in the sensitivity, contrast and colour saturation of the final print material. Tackiness or viscosity of the mixture is diminished when water is added. With a less tacky solution the emulsion will coat more thinly. This change in coating thickness causes the other changes in physical characteristics.

The classic method of mucilage preparation is to make up a solution of 30% gum arabic from natural gum crystals, a solution of 10% ammonium bichromate, then add ½in of tube watercolour. This method is unsatisfactory as accurate estimation of the water content of this mixture is almost impossible to obtain and the precise control of the quantity of water in the mucilage is essential.

The ideal method would be to reduce all the constituents to dessicated powder then add a measured amount of water, but in practice it is not necessary to go this far. An equally efficient method which is simple to operate is to use only one constituent in solution form, then balance up with the other two constituents as dry powder so that the amount of water present will always be constant. Commercially manufactured gum solutions or branded office gums have all proved to be extremely useful when using this method. An added bonus with this type of gum solution is that as it is manufactured on a vast scale its physical characteristics remain almost constant. The pigment is added as dry colour and the ammonium bichromate as chemical salt. The gum to bichromate ratio can easily be kept constant with resultant stabilization of the light sensitivity and contrast characteristics of the emulsion. Variation in the amount of pigment present in the coating will, of course, change the colour. This affects the water to solid ratio but, as the total amount of colour is normally quite small, such a minor change in viscosity will not have a significant effect on the sunprinting characteristics of the final gum coating. This method of mucilage preparation ensures a constant and highly reproducable gum coating time after time. This consistency allows the gumprinter freedom to modify technique in a planned manner and be confident of achieving accurate results.

A unique and exciting characteristic of the gum pigment process is the ease with which it can be coated onto all types of surface and the fact that it is quite possible to coat a number of times onto the same base simply by coating, re-exposure and development. Either the original image can be used or, alternatively, different images can be printed down in succession. Multiple printing of this nature provides enormous scope for creative exploitation.

Gumprinting has a very similar image quality to water colour painting. It lends itself to the same soft atmospheric colour relationships, subtle tones and pastel colours. Subject matter such as watery landscapes and children will have just the right kind of character to suit this delicate process. Printmaking with gum will reveal image qualities which for sheer creative expression are seldom found in other picture making techniques. When a sensitive choice of subject matter is undertaken,

42

there is no process which quite matches the subtlety of gumprinting.

The process can also be manipulated to a remarkable extent. During development tones can be weakened or completely removed, and after drying pastels and crayons can be used to strengthen and darken tonal values. Rubbers and scalpels are sometimes used to clean up highlight values and to remove unwanted detail not removed during development.

It must be understood, however, that the use of these autographic techniques is by no means essential for the successful application of this form of sunprinting. Very beautiful results can be obtained without any manipulation at all. Manipulation is very easy in gumprinting because of the nature of the process. How much, if any, manipulation is used depends on the personal taste of the gumprinter and the creative demands of the picture.

Pigment stain One of the great limitations of the gumprinting process is the problem of pigment stain. This type of stain degrades the light tones (highlights) and generally reduces any white tonal value to a colour or grey tone. It manifests itself in an overall desaturation of colour and a reduction of tonal contrast. The general effect is the production of a gumprint which has a dark unpleasant quality, masking the full power and beauty of the process. This fault is exaggerated when multiple printing is attempted where each printing stage is followed by an increasing magnification of pigment stain, until finally the print is so desaturated that it is totally unacceptable as a piece of creative work. Slight pigment stain can on occasion give a creative quality similar to the plate tone of an etching. If the fault is used in this manner it is perfectly acceptable, the final results being judged on their own merits.

Pigment stain is caused by three separate defects which act simultaneously. The first defect results from particles of pigment getting trapped in the fibres of the paper base. This form of stain can be entirely eliminated by selecting and preparing the base material correctly.

The second form of stain is known as bichromate stain and occurs through the action of light on the bichromated gum and is directly caused by the bichromate itself. It is not, therefore, a pigment stain in the true sense. Partial correction of this stain is possible if the recommended fixation procedure is carefully followed.

The final source of pigment stain, which is also the most troublesome, is a type of dye stain caused by the use of cheap, poor quality pigments. It is virtually impossible to correct this type of stain. It is, therefore, wise to always use the best quality artists' dry colour powders, although these tend to be expensive. This type of pigment will not stain, and as a small amount is used it is false economy to use cheap varieties. If care is taken pigment stain will not seriously interfere with the successful operation of the gum process.

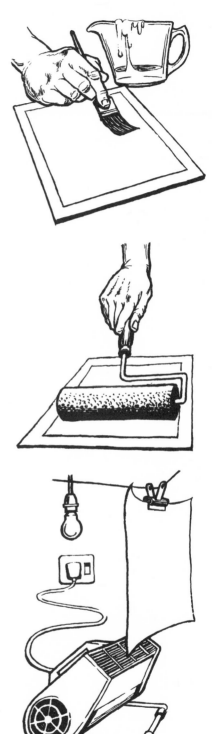

Base materials Almost any material can be used as a base for gum-printing as long as it is correctly prepared. Materials such as paper, wood, glass, plastic, fabric, metal and clay can be suitable for this process. The only materials which are not usable are those having a greasy quality to their surface as the gum mixture will be strongly repelled by this type of surface and coating will be impossible.

A material's surface has a strong effect on the final result of this process. Whether a surface is porous or non-porous in character is an important consideration. A material can exist in either of these two conditions, for example, softwood, in its natural state, has a porous surface, whereas hardwood, polished and sealed with one of the proprietary plastic sealers can be said to have a non-porous surface. Another example is glass, obviously a non-porous surface, but when it is ground it becomes porous in character. The degree of porousness will vary from material to material and will have a dramatic effect on the appearance of the resultant image.

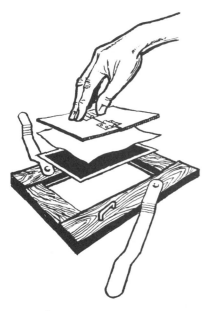

A non-porous base is useful when a high degree of image definition is required. It is also resistant to pigment stain, by virtue of the fact that there is nothing to hold the pigment particles. It has no effect on the bichromate stain which is a function of the gum and not the base. This type of base also suffers from the fact that only a relatively thin coating can be achieved. Therefore, multiple printing techniques must be employed when a strong saturated result is required.

Porous bases have the advantage that when the gum mixture sinks into the pores of the base, the same pores act as if they were a skeletal structure on which the pigmented gum clings. This coating is then more permanently held than an equivalent coating on a non-porous base. The coating can, therefore, be much thicker, giving a richer more highly saturated image.

This increase in the strength of image is, however, gained at the expense of image definition—the more porous the base, the greater the loss of definition. Photographic papers show a similar set of characteristics when the definition obtained on a glossy surface is compared to that on matt surface, but this difference is far greater when applied to gumprinting.

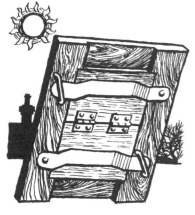

As the structure of the base gets rougher it breaks up the image to a greater extent. This effect can be very satisfying from an aesthetic point of view, giving an exciting new dimension to creative sunprinting. Most porous surfaces must be especially prepared before use otherwise serious pigment stain will make the result disappointing and unusable. Porous surfaces can be prepared by sizing with either arrowroot, starch, weak gelatin or one of the new PVA materials used with acrylic paints. The sizing materials are painted onto the porous surface using a stiff brush, allowed to dry and then soaked in a suitable hardening solution, for example, chrome alum, potassium alum, or formalin, then washed and dried. The PVA needs only to be painted onto the surface and

44

allowed to dry—once dry it will be in the right condition without further hardening. From this point of view it is more useful than the former agents. Gelatin is the best sizing agent as it repels the pigment particles more effectively than any other agent.

Ready sized papers can be obtained which need little or no preparation. Best quality artists' water colour paper is very suitable in this respect. Photographic paper which has been cleared of silver by fixation and washed thoroughly is very suitable as a prepared base. Old prints can be pressed into service by bleaching them in a strong solution of Farmer's reducer or iodine reducer, and thoroughly washing afterwards. The advantage of a ready prepared base is that the process then requires one less working stage.

Kodak mural paper provides a surface which is absolutely right for gumprinting. It has a thick surface texture thinly coated with gelatin and will hold a good thick coating of pigmented gum without excessive exposure or loss of definition. On development, the highlights clear to a pure white, adding sparkle and lustre to the print. The only problem is that this paper is only available in rolls obtained directly from Kodak, but once purchased, it is very economical to use, as a great many sheets of paper can be cut from the roll.

Resin coated paper supplied by most photographic manufacturers has some remarkable physical characteristics which make it very suitable for gumprinting. The resin coating seals the paper almost completely providing a surface almost totally resistant to a pigment stain. An additional quality of this type of paper is that it has improved dimensional stability. These two advantages are particularly important for multiple printing. The only disadvantage is that being non-porous in character, depth of coating is restricted, but with careful multiple printing this problem is easily overcome.

When preparing a porous surface several coats of size may be required. In these circumstances do not start printing until the correct amount of size has been ascertained—when in doubt give another coating. It is impossible to size too heavily but quite possible not to give enough preparation, which is likely to cause pigment stain.

Coating procedure Coating with gum mixture is a critical stage in the process. If the coating is not even, this unevenness will show in the final image. Coating evenly is a difficult process to master. Only a very thin coating is necessary, therefore any slight inequality in the coating shows up very strongly in the printed image.

There are three acceptable methods of coating which can be used. The first method is the traditional one where two brushes are used. One, similar to a paint brush, is used to spread the coating as evenly as possible. The second, known as a badger hair softener, is used to stipple the surface smooth as the coating dries. A considerable amount of manipulative skill is required to get an even, smooth coat.

45

The second acceptable method is to use a spray gun which gives a very smooth, even coating, but unfortunately is a very expensive piece of equipment and again requires skilful application.

The third and final method is to use an inexpensive latex foam painting roller. This type of roller gives a very even coating and at the same time a fine granular texture to the surface of the image. This textural quality is not detrimental, but donates to the gum process a certain tactile quality that is visually pleasing. If a smooth surface quality is required it is quite easy to obtain by simply coating thinly and double printing. The texture of one image will be cancelled by the texture of the second to produce a smooth tone without texture.

A smooth coating can also be obtained by rolling the mucilage onto the base material with the foam roller and leaving it for three to five minutes until it is very tacky. Then roll the coating with a second *dry* roller, which should immediately smooth out the texture imparted by the first roller. It is very important that the second roller is perfectly dry for the successful operation of this coating method.

Sometimes an uneven coating will provide a result which is creatively more interesting than a smooth coating, particularly if experimental work is to be undertaken. In this case try to use a very coarse brush such as a paste brush to give an uneven stipple, dabbing the surface of the coating material with fabric or hessian. This will impart a rough, hard texture to the coating which will show through onto the surface of the gum image, giving a handcrafted effect to the final printed result.

Coating thickness Control over the thickness of the light sensitive gum coating is vital to the successful operation of this process. A practical limit to the thickness of the gum coating is determined by the exposure required to create a print. The thicker the coat, the greater the exposure required, until a point is reached where no increase in exposure will print all of the image through to the paper base. On development the image will float off the base completely, only sticking to the shadow areas. If too thin a coating is used, a weak, desaturated image will result.

An indication of correct coating thickness can be gained by a simple test, but this only works on translucent paper bases. View the coating plus base by transmitted light and hold a finger behind it. If a shadow of the finger can just be seen, the coating is correct. On the other hand if no shadow can be seen, the coating is too thick. If the shadow of the finger can be seen very clearly, then the coating is too thin.

There is generally a tendency to coat too thickly at the first attempt. If in doubt coat on the thin side, then if the image is too weak, recoat and multiple print to get the required strength of image.

Dark reaction The coating must be mixed and coated at the same time and the print material should be exposed as soon as possible after

coating and drying. The reason for this haste is that a bichromated colloid suffers from a condition known as dark reaction. The effect of this is to spontaneously harden the colloid without exposure to sunlight. The effect is usually noticed when the coated material is left several days before exposure.

A similar effect known as heat fogging can occur when a coated material is dried too quickly. If the coating is dried with a fierce radiant heat it will spontaneously harden in a similar manner to dark reaction and will be useless for subsequent exposure.

Drying To dry, place the coated base material in a dark, dry and dust-free room where there is a good circulation of air. Leave for one or two hours to dry at normal room temperature. Drying can be speeded up by the use of a hairdryer, but caution must be exercised not to overheat the material, otherwise heat fogging will result. Where possible, coat and dry the evening before a day's printing so that the gum coating can be thoroughly dry. The gum coating, once it is dry, can be handled with ease.

Exposure Once prepared, photographic emulsions have a particular sensitivity to light, usually expressed as a film speed index (ASA, DIN). This index enables exposure to be calculated with a reasonable degree of accuracy. Unfortunately, the gum emulsion by its nature is not consistent in its light sensitivity, making the accurate calculation of exposure impossible.

The reason for this inconsistency is that gum sensitivity to light relies on a balance of three variables: the chemical mixture of the mucilage, the coating thickness and finally the structure of the base material. These three variables in themselves also need control if reproducable results are to be obtained. The control of these variables has been fully discussed on pages 18, 19, 20. The important factor to realize is that to give a precise film speed would mean that all three of these variables would have to be strictly controlled in relationship to each other. This control is possible to achieve, but only at the sacrifice of the freedom and versatility of the process.

This freedom of expression and versatility is what makes gumprinting such an exciting and unique method of sunprinting. Fortunately, there is enough latitude in the actual practice of gumprinting exposure to make rigid adherence to an emulsion speed index system unnecessary.

During exposure the printed image slowly becomes visible. It *prints out*, to use the terminology of the silver print out process. Exposure is judged to be correct when the printed out image in the gum layer shows full highlight detail. Generally, the image should be slightly darker than finally required, as a small loss in print density occurs on completion of the process.

Other factors can change the apparent sensitivity of the gum emulsion.

The commercial gum arabic solutions vary from brand to brand, as different manufacturers blend their gum solutions to maintain consistency. A number of gums are used in this blending process. Therefore, it is a wise policy to make a choice of one commercial gum solution, stick to it, and get to know it thoroughly.

The pigment content also has a small effect on gum sensitivity. Lighter pigments give faster emulsions than darker pigments. Colour on the other hand has little effect on overall sensitivity. Multiple printing seems to modify exposure, making more exposure necessary, probably due to increased absorption of light by the underlying pigment images.

Exposure to daylight for between five and fifteen minutes should be correct. Always use daylight for exposure, and try to avoid direct sunlight. If direct sunlight has to be used, the exposure will need to be reduced to between one and five minutes. The problem with direct sunlight is that there is a very high radiant heat output from the sun, as well as the useful actinic light. This radiant heat can cause heat fogging when exposure times exceed five minutes. Until recently it was thought that the sensitized gum was primarily sensitive to light rich in ultra-violet radiation, but practical tests by the author seem to indicate that light in the blue/green area of the electromagnetic spectrum is the most actinic for this process.

The gum process is inherently low in contrast, due to a thin coating layer married to a bichromate image. The bichromate induces a variable solubility between the exposed and unexposed gum, but in addition it also produces tone in a form of an oxidized stain in the gum layer itself. In this way an image of continuous tone is made. This dual function of solubility and stain tone gives the process some of the attributes of both the carbon and silver processes, but without the range of contrast on either. A strong, vigorous negative of high contrast and minimum density should be employed to counteract the inherent low contrast and lack of sensitivity of the process. Enlarged negatives made from colour transparencies are ideal for use in gumprinting.

Development Development is effected by floating the print, face down, on cold clean water contained in a deep dish, placed in a sink fitted with a cold water tap. After the print has been soaking for about ten minutes it should be carefully examined. If all is going well, the unexposed gum from the highlight areas will begin to stream away from the image. At this stage the print surface is extremely tender and must be treated with great care. On no account should it be touched or immediate damage will result. After soaking, place the print, face up, upon a sheet of glass held vertically over the sink. Using a thin rubber tube connected to the water tap as a hose, gently wash off the remaining unexposed gum coating until the tones of the images are fully revealed in their correct proportions.

Taken on the Thames embankment one November morning on 6 × 6 cm Tri-X film. The final enlarged negative was made from a number of paper intermediates both negative and positive and sunprinted by the use of the gum-bichromate process.

These buildings were photographed on 35 mm FP4 film, then converted into a texture tone enlarged negative by the use of the collotype process described in Chapter 2. A moody final image was obtained by the use of the gum-bichromate process.

English seafront on a misty October morning—6 × 6 cm Tri-X film. The original negative was printed via a number of intermediate separations to produce an enlarged negative suitable for oil print production and subsequent transfer by the use of a mangle or etching press as described in Chapter 3.

These salt marshes were photographed in mid-winter on 6 × 6 cm Tri-X film. The resultant negative was enlarged directly onto Kodak P84 document photographic paper, then this enlargement was contacted onto high contrast film and sunprinted using the gum-bichromate process.

If, after soaking for ten minutes, the print does not begin to develop as described, it was probably overexposed. Partial correction can sometimes be effected by raising the temperature of the development bath or by the addition of a few drops of ammonia. As in normal photography, underexposure cannot be corrected. This becomes readily apparent when, on immersing the print in the developer, the pigmented gum streams off the base material leaving only a very faint, partially dissolved image which is impossible to use.

Fixation When the gumprint has received sufficient development it will still be necessary to clear the yellow bichromate stain left on the coating so that the true colour will show. To clear this stain the developed print is immersed in a 5% solution of acid hardener which is normally used as an additive to an acid hardening fixing bath. Acid hardeners usually contain sodium or potassium bisulphite, which clears the stain, and chrome alum which hardens the gum coating.

The fixed print should be given a short wash in fresh water then hung up to dry. Do not use any kind of pressure blotting paper as the surface of the print is still very tender.

Multiple printing Multiple printing allows a number of impressions to be printed, one on top of another, on the same base. This direct printing feature is unusual. In other sunprinting processes the images are printed separately and then assembled to form the final multiple print. For sheer flexibility this method of print-making cannot be equalled. The colour, density and contrast of the image can be changed at will and provides a remedy for the short tonal scale quality of the gumprint. Underexposure can also be easily corrected when working this method.

Pigment stain limits the number of printings possible. This fault is difficult to control as the chemistry of the process is contained within each printed layer, so even if this defect is kept to the minimum by careful technique, as each layer is printed, more and more stain is bound to build up. The bichromate stain proves to be the most troublesome. The other elements of pigment stain can, to a very great extent, be controlled.

Another problem in the practice of multiple gumprinting is one of registration. All assemblage processes suffer from this problem. The gumprint during the printing process goes through a number of wet and dry stages. At each of these stages the paper base material expands and contracts, quite often changing its dimensions by a significant amount. To avoid these dimensional distortions and the resulting problems of image registration, it is best to choose a base material resistant to dimensional expansion and contraction such as resin coated photographic paper, polyester film mounted on white paper, white plastic, or etching paper with a high rag content. Once dimensional stability is achieved the use of a punch register system efficiently solves most of

the registration problems which can occur in multiple gumprinting.

A staggering range of creative choice lies before the gumprinter, from the simple duotone to the complexity of a tricolour print. Composition and aesthetic considerations must govern the relationships between images. When images are multiple printed down onto a base, previsualization is difficult but necessary. Sometimes it can be useful if the images are first printed down on celluloid before final assemblage so that they can be put together to see if they work in relation to each other. If they do not, further changes can be made until a satisfactory combination is achieved, and final printing can proceed.

The gumprinter takes part in a truly creative act when he multiple prints. He controls each tone, image and colour in an almost godlike manner and if the result is unsatisfactory, he has no devil to blame except himself. Multiple printing can be the most exasperating and at the same time the most satisfying and stimulating pastime possible.

Conclusion Picture making by the gumprinting process offers a method of great versatility where the surface quality of the image can be transformed at will. The colour, texture and tonal values of the pictures are under the complete control of the photographer, giving this process a degree of flexibility and creative freedom unequalled by any other photographic image-making system.

It is a simple, direct and very open-ended system, cheap to operate and fast to work. It is interesting to speculate why with all these advantages, the gum process has not gained greater popularity. After all, it has been around for a very long time. A simple answer could be that it is a difficult process to control precisely. The gumprinter also not only has to use his light sensitive material but also manufacture it, a role which the modern photographer has delegated to others. Only when the gumprinter employs the same discipline and rigid control of technique, associated with the commercial manufacture of photographic materials, can he hope to gain mastery of the process.

Mastery can be achieved but always remember that the correct compounding of the gum mucilage is the key to success. This is where the problem for the beginner usually occurs. It is so easy to experiment with different quantities and proportions until the original purpose and control of the chemical balance of the mixture is lost. The gum mixture looks and acts just like the paint that we all splashed around as children. It is far too easy to forget that this is not just some gummy paint, but in fact a precise photochemical compound which has to be mixed, coated and processed in an accurate scientific manner. When an empirical, slap-happy approach is adopted disastrous results are bound to follow. Being a water based medium its physical action is very fluid. Water based mediums usually require very careful control, for instance, in painting, watercolour is renowned for its difficulty of use, whereas oil paint is much easier to manage as it is much stiffer and less fluid in its action.

It is strange that this method has not appealed to other artists in fields of activity closely allied to photography. The autographic print-maker uses gum arabic extensively and has had mastery over pigment for centuries. Problems of registration, multiple printing, pigment mucilages are well understood in these fields. Perhaps a dichotomy between the photographic and autographic similar to the painting/photography controversy has delayed the application of gumprinting in these areas. The gum image could also be of great value to the painter possibly as a base image instead of a drawing.

Advanced colour photography offers the greatest challenge to the creative gumprinter. This is an area that has been hardly touched yet and is waiting for creative exploration. Gumprinting with its characteristic of complete personal control over the components of a picture should be perfectly suited to this task. The gumprint when made with sensitivity and technical skill has a haunting beauty hard to define in words, but which remains softly and intensely alive in the memory.

CARBON

History The carbon process came into being as a result of the search for a permanent photographic process which would not fade or spoil due to the effects of age. Silver processes were notorious for their lack of stability.

In the original process carbon was used as the image colourant, as it is chemically inert and ideal for the production of permanent images in bichromated gelatin.

The carbon tissue has generally become accepted as a term to describe a thick pigmented layer of gelatin coated onto a paper base which can be sensitized to sunlight by the addition of a bichromate salt, in a similar manner to the gum and oil processes already discussed.

The French chemist, Alphonse Poitevin patented the original process in 1855 and J Pouncy was the first to produce photographs by this process in 1858. In this early process the tonal gradation was most unsatisfactory, a problem which was elegantly solved by Sir Joseph Swan in 1864, when he introduced a method of image transfer which allowed all the exposed tones from highlights to shadows to be faithfully recorded. Further improvements were made by J R Johnson and J R Sawyer in 1869 and 1874 respectively. The carbon process has been applied to high quality photographic print-making for nearly a century, becoming almost obsolete in the early 1950s when the Autotype Company founded by Sir John Swan ceased the manufacture of carbon tissue suitable for this process, the only remaining manufacturer being Franz Hanfstaengl of Munich.

Carbon has always been associated with tonal fidelity. Prints of a very long tonal gradation can be easily made. The process is capable of

producing smooth tones of great textural beauty which cannot be equalled by any other pigment process. For this reason and coupled to the fact that the process is not easily manipulated, it immediately found favour with the traditional school of photography, and was enthusiastically employed for a great many years.

A system of trichromatic colour print-making evolved which many experts on colour photography still consider far superior to present day colour print systems. Also a variant of carbon known as *carbro* was developed, allowing the use of bromide prints to produce the image layer instead of exposure via enlarged negatives, further simplifying the processes for the amateur worker.

Owing to the present shortage of suitable material to work the process, the modern carbon worker is well advised to produce his own

tissue. This course of action is not as difficult as it would at first seem and does open up areas of personal choice not possible with the manufactured product. A great amount of control can be exercised over image colour and the character base, allowing sensitive and highly personal creative pictures to be made. The act of making your own tissue is great fun.

Basic process Carbon is very similar to the gum process in that the image is produced by water solubility of the non-image areas. The main difference lies in the nature of the colloidal layer. In gumprinting the layer is extremely thin, partly because of the nature of gum material itself, but more so because of the method of printing. The gum process is printed directly whereas the carbon is indirectly printed, that is, the

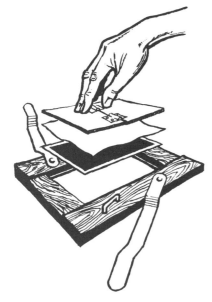

image has to be transferred from its original base onto an accepting base after exposure and just before development.

Pigment is used as the image colourant and gelatin acts as the binder. Ammonium bichromate sensitizes the gelatin binder to sunlight in the normal manner of a bichromated colloid.

The carbon tissue consists of a thick layer of gelatin and pigment coated onto a paper base. The sensitizer can be incorporated in the layer or applied later to the layer by the use of a spirit sensitizer. The image is formed by exposure to sunlight of a continuous tone negative in contact with the tissue, after which the carbon tissue is placed in a bath of cold water and brought into contact with the final support. They are then withdrawn together and squeezed together in contact to form a pack and allowed to half dry. At this stage development can take place. The pack is placed in hot water and the unexposed gelatin oozes out of the pack. The tissue can then be stripped from the final support and discarded. The image should slowly appear on the final support when it is gently bathed with the warm water. This process of development is extremely satisfying to watch and adds a little magic to the process. When all the soluble gelatin has dissolved, the print is given a brief fix in dilute acid hardener and hung up to dry in a stream of warm air.

To understand how the image is formed in the carbon process, it must be realized that the front surface of the tissue lies on the base of the final support and if the image is viewed edge on, the shadows stand up in relief just like a mountain range, whereas the highlights conform to the valleys of this imaginary landscape. The greater the relief of a tonal area the darker the tone in the final image. Originally this relief was formed in the tissue by the action of light sinking down into the sensitized gelatin layer. The greater the exposure the greater the gelatin relief and subsequent depth of tone in the final picture. This physical quality of the carbon image is quite unique and gives the image an amazing degree of tonal fidelity, with little or no tonal distortion in the highlight and shadow areas of the image, an added bonus provided by this high quality process.

Transfer is a basic requirement of the process. If the tissue is developed without a final support, the image would simply float off the tissue base and spoil. All the problems of the process tend to revolve around the transfer procedure which requires some degree of mechanical skill or knack, otherwise air bubbles and random marks tend to spoil the image. The tissue and transfer support must be in the correct condition to receive each other and careful attention must be paid to this critical stage in the operation.

Transfer on the other hand does allow a considerable choice of base such as paper, cloth, ceramic tiles, glass, wood, ivory, metal etc. Given that the base material has been correctly prepared to receive the image, all kinds of creative possibilities become open to exploitation by the

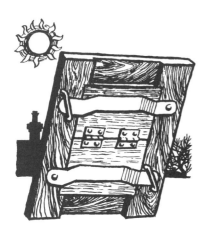

carbon printer. A number of images can be built up by this process in the form of a multiple print but as a carbon image is dense by nature, there is a natural limit to the number of images that can be superimposed upon each other. More than three printings become difficult to control.

Tissue manufacture Coating the gelatin onto a paper base is not as easy as coating binders in the other processes, due to the basic nature of gelatin, which must first set like a dessert jelly and then is very slowly dried. Gelatin does not respond to the paint brush or roller coating technique, and to coat successfully it must be allowed to flow onto the paper base.

The paper used as a base material must be smooth surfaced, thin, with strong water resistance. The back of fixed out photographic,

55

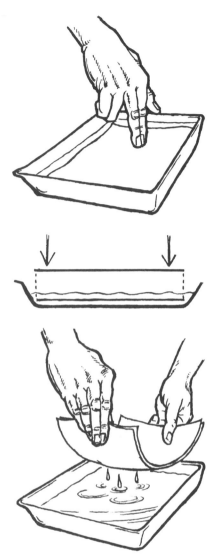

document or good quality watercolour paper should act well as a carbon tissue base material.

There are three methods of actually producing the tissue. The first method is to place the gelatin solution in a tray which is then positioned in another larger tray containing hot water to keep the gelatin mixture liquid. Carefully lower the paper base onto the surface of the solution and allow it to float for two to three minutes. Make sure no air bubbles are trapped under the paper or holes will result in the final coating. Then lift the paper smoothly up and out of the tray, lay it out level for a few minutes, so that the gelatin sets. Then hang it up to dry.

The second method is to place a paper base on a glass base which has been carefully levelled. Pour a pool of gelatin mixture onto the centre of the paper and smooth out using a glass rod, until an even coat is obtained. Allow it to set and then hang up to dry.

The third method is the most economical and easy to work. A frame must be made out of wood or metal and a sheet of glass or Formica, the same size as the outside dimensions of the frame is needed. Cut the paper to the size of the glass, dampen it and squeegee it flat onto the glass. Clamp the frame onto the glass plus paper with gee clamps or bulldog clips. This forms a dish, the bottom of which is the paper base. Quickly pour the pigmented gelatin into the dish until it is half full. Then very quickly pour it out again, place the frame in a level position and allow the thin film remaining to set. Then unclamp and remove the frame. Hang the paper up to dry in a stream of warm air not hotter than 27C (80F) or the gelatin coating will reliquify and spoil the coating.

The secret of coating gelatin evenly by any of these methods is to get the mixture to the right viscosity or thickness. A comparatively thick mixture is required and it should have the character of a syrup. Surface tension determines the thickness of the final coating, as also does the temperature of the gelatin mixture which must be maintained at a constant value between 38C (100F) and 66C (150F). If the temperature is not maintained at this constant value, 50C (122F) for instance, variation in the thickness of the final coating will occur.

A carpenter's glue pot is useful to keep the gelatin mixture liquid and at a constant temperature, or a pyrex measuring jug placed in a large saucepan full of hot water will work just as well. The temperature can be kept constant by the use of a tropical fish tank heater thermostat placed in the saucepan.

Air bubbles sometimes give trouble in coating, but they can be removed if prompt action is taken before the gelatin coating begins to set. Take a small piece of fluffless blotting paper and poke a corner of it right into the air bubble. The latter will then usually burst and the coating smooth out of its own accord.

Add water colour pigment, in dry pigment form, to the gelatin coat. The amount of pigment varies according to the nature of the final image, but may be anything between 5% and 30%. Glycerine is added

to the order of 5%. This constituent keeps the dried tissue pliable. Sugar is also added, again in a small amount, about 5%, which helps to make the unexposed gelatin quickly soluble. The sensitizer and bichromate can be added at this stage or left until later and applied as a spirit sensitizer. The problem with incorporating the sensitizer in the tissue at the manufacturing stage is the common ailment which all bichromated colloids suffer from—dark reaction. If the sensitizer is incorporated, then the tissue will have to be used almost immediately or spontaneous hardening will take place.

The final and most important constituent is gelatin which should be between 20% and 30% of the mixture. This is a thick viscous solution. The gelatin will need to be soaked for two to three hours in warm water to achieve this degree of viscosity. The best way to do this is to tie up the dry gelatin in a bag made of cheesecloth or cotton and suspend it in a jug containing the correct amount of warm water. It is advisable to use distilled water when possible. When the gelatin has completely dissolved, the other constituents can be added and the mixture slowly brought up to the coating temperature i.e. between 38C (100F) and 66C (150F).

The gelatin used for tissue manufacture can be of the domestic colourless kind sold for cooking and culinary purposes. This gelatin tends to be rather soft and can give problems in coating. A good gelatin is Nelson No. 1 which can be obtained from printing and lithographic suppliers or screen printing suppliers.

When manufacturing tissues great care must be taken not to overheat the gelatin mixture. Too high a temperature or too long a time of heating will destroy the gelatinous nature of the mixture.

As previously stated, the drying of the tissue after manufacture is critical. It is imperative that the tissue is dried slowly in a stream of warm air, no hotter than 29C (85F). Using an electric hairdryer or fan heater, the tissue should take between 30 minutes and two hours to dry, depending on the thickness of the coating.

Tissue coating tends to be a messy business so it is a good idea to make a large batch of tissues at one time and store them for future use—an ideal job for winter evenings when sunprinting cannot take place.

Sensitization This can take place during manufacture of the tissue or with the use of what is known as a spirit sensitizer which is made up of two parts methylated spirit or industrial alcohol and one part ammonium bichromate solution, the percentage of which is governed by the requirements of the final print image.

To sensitize the tissue immerse it in the dish containing the spirit sensitizer for one minute. Then remove the tissue and dry it for ten to fifteen minutes in a stream of warm air. At this stage it becomes sensitive to light and should only be handled in weak artificial light to avoid the risk of fogging.

The percentage of bichromate in the spirit sensitizer controls both the light sensitivity of the emulsion and its contrast. The weaker the solution on the bichromate, the higher the contrast, and less sensitive to exposure the coating. Tissue sensitized in a 1% bath requires three to four times the exposure necessary for tissue sensitized in a 5% bath.

It is possible to apply the spirit sensitizer with a wad of cotton wool in the form of a buckle brush. When using this method, make sure your fingers do not touch the surface of the tissue which can easily be damaged at this stage. Also, when using the immersion in a dish technique remove any bubbles which may form on the surface of the tissue.

When sensitization is finished, it is an advantage to place the tissue face down on a clean sheet of glass and lightly squeegee off the excess sensitizer from the back of the print. This will allow the print to dry faster and helps to eliminate drying marks which sometimes give uneven results.

The percentage of the ammonium bichromate to the total solution of the spirit sensitizer controls the contrast of the tissue. A 5% solution gives low contrast, 2% to 3% normal contrast and 1% to 0.5% gives high contrast. The make of gelatin used also has an effect on contrast. Prints made using cooking gelatin are very soft, whereas Nelson's No. 1 gelatin has much more inherent contrast.

Exposure estimation The exposed image in the carbon process is not visible to any great extent. Therefore, either a simple test strip technique, as worked in normal photographic printmaking, must be used or a more accurate alternative method, such as the use of an actinometer as previously described. (*see* Chapter 1)

The latter technique ensures consistently correct exposure, and saves a great deal of time and trouble. There is an added bonus when the actinometer is employed to gauge correct exposure as it automatically adjusts to light intensity fluctuation. This means that sunprinting can be undertaken even when the light level is very low.

An ideal negative suitable for carbon printing should have plenty of contrast but not be too dense. A 'thin' negative with a full range of tones is correct for this process. The negative will need a *safe edge*. This consists of a narrow opaque border of about 8mm ($\frac{1}{3}$in) wide. Either an opaque paper mask or red lithographic tape should be adequate for this purpose. The object of this safe edge is to ensure a soluble margin on the exposed tissue which obviates any risk of the picture edge washing up or frilling during the process of development.

Final support preparation The final support needs to be in such a condition that it will readily stick to the tissue surface when the two are brought together in the pre-transfer bath. The easiest way of accomplishing this is to coat the final support with a thin coating of soft cooking gelatin, then *just* harden it in a 2% bath of potassium alum so

that it does not dissolve in the development process, but on the other hand remains sticky enough to attach itself to the hardened surface of the tissue image. A 1% solution of cooking gelatin will work well. This solution can be applied with a blanchard brush onto the paper base. If other base materials such as glass or plastic are used, it is better if this coating is applied with a wide camel hair brush.

Pre-transfer The pre-transfer bath should contain cold clean water. First, the transfer support is placed in the water for a few minutes. The transfer support, known as the final support, must be at least 2 cm (1 in) larger on each dimension than the tissue to ensure a safe handling edge of 1cm (½in) all round the print. The exposed tissue is now placed in the water bath. The tissue immediately curls up on entering the water, then slowly uncurls. When it is half way uncurled, it should be brought into contact with the final support and placed in the centre of the support face to face. Quickly remove both tissue and support from the bath, place on a sheet of glass, and lightly but firmly squeegee them together to form a pack. This pack is now placed between blotting boards and light pressure applied by positioning a pile of books on top of the pack for ten to twenty minutes when the pack should then be ready for development.

Development Commence development by immersing the pack into a bath of water at 38–43C (100–110F). In a short time, usually one to three minutes, a stream of soluble pigmented gelatin starts to ooze out of the edges of the pack. After a minute or so one of the corners of the tissue will begin to rise as it becomes clear of soluble gelatin. At this stage, grasp a corner and gently strip the tissue from the final support, and discard it. Bathe the final support gently with warm water. The image in the form of a film of insoluble gelatin will slowly appear. Non-image areas will show as an overall oozing mud which gradually clears and dissolves to reveal the final image.

Fixation The carbon print is then given several rinses of clean cold water to remove all traces of soluble pigmented gelatin and placed in a fixing bath containing a 5% solution of acid hardener, which should clear all residual bichromate stain and harden the image. Then give the print a further rinse in clean water containing a few drops of wetting agent and hang up to dry. Hot air can be used instead of just warm air, which speeds up the drying procedure. Remember that the image is still very fragile, despite the hardening, so exercise care in handling.

Transfer On transfer, the image takes the form of a mirror image, that is, it is reversed from left to right. There is a method which produces prints the correct way round. This is known as double transfer, but it is complex to operate. It is easier when making the enlarged

negative to simply reverse the negative during the enlargement procedure—this produces a correctly orientated final image.

Conclusion The popularity of the carbon process for so many years is not hard to understand. It contains all the beauty of a continuous tone process and the textural quality of the pigment processes, allowing a tremendous variety of base texture and pigment colour. Why then has this process, with so much going for it, become almost obsolete? The major reason is that it requires a high degree of manipulative skill. This takes time to acquire and many people do not have the patience to learn in these days of the instant experience and preprogrammed technique. It is very heartwarming, however, to see some rebirth of interest in these antique processes at the present time.

OILPRINTING

History We can again look to Alphonse Poitevin for the origination of the oil process. He patented this in 1855. From this patent have developed the collotype and bromoil processes. Even the principles underlying the basic mechanism of screenless photolithography were foreseen. The lithographic principle which underlies the oil process relies on the mutual repulsion of oil and water. This was discovered accidentally by Alios Senefelder who in 1798 marked a polished limestone surface with a greasy crayon with which he was making out a shopping list, only to find when he cleaned off the crayon image, a greasy mark was left on the limestone surface. This could not be removed. In fact, it strongly rejected any water used to try and wash it away. The limestone around the greasy image did accept water readily. So one part of the stone accepted water and another part did not. The stone surface was then dampened and a roller charged with a stiff greasy ink was rolled across the image. To Senefelder's delight the ink only took on the greasy image area of the stone, not on the dampened portions. This new image could be simply offset onto a clean sheet of paper and the limestone damped with more water, then re-inked for further printing. This was a completely new printing process different in principle to either the intaglio or the relief processes which were its precursors, and provided a truly planographic method of printing.

Rawlings patented another photographic oilprinting process in 1904, but this was little more than a modification of the earlier process of Poitevin. Rawlings advised the use of brushes to apply the ink rather than the more mechanical rollers used previously. This brush technique made possible a great freedom of execution in the way the tones could be recorded. With manual dexterity a tremendous amount of personal control could be exercised. Tones could be lightened or darkened at will and image detail accentuated or subdued entirely to the personal taste

Creatively, this was a major breakthrough for the 'artist' photographer as the Photo-Secessionist photographers of the day preferred to be known. The process offered greater freedom and flexibility to manipulate the image than even the gumprint method. Problems of pigment stain, the great limitation of the latter process, did not apply as the pigment was safely contained in the varnish and oil binder of the ink. As brushes were employed even the surface quality of the oilprint had a strong resemblance to an oil painting. It was predictable that this painting-like quality should cause howls of dismay and ridicule from the photographic purists of the time. In addition to this outcry, the portrait painters added their own vilification—perfectly understandable when one considers that their livelihood was threatened by this new form of photographic representation.

Robert Demachy, the pioneer of the use of the gumprint as a means of art photography, developed a radical extension of the oil process, known as the *oil transfer*. He found that it was perfectly feasible to transfer the oil image from the original gelatin coated base onto a fresh piece of paper, by simply passing both the oilprint and transfer paper through an etching press under pressure, exploiting familiar autographic print-making technique.

The transfer print produced by this method has a totally different image quality to any other form of sunprinting, indeed, it is even different from the original oilprint from which it was transferred; distinctly nonphotographic in character, more closely resembling a lithographic image than a photographic print. The final print consists of nothing but an image in ink resting on a paper base; no side products to interfere or spoil the simple purity of the process.

The oil transfer method offers a universal range of manipulative control. Parts of the image can be printed down separately time and again, colours of tones changed, detail in the image subdued, or exaggerated, to suit the artistic aspirations of the oilprinter.

As long as a base material can go through the press without damage, the oil image will print onto it. The sticky nature of the ink ensures its adhesion to almost any surface. This allows a wide choice of base material, a further creative bonus for this system of print-making.

Both the oil and transfer prints have a surface quality typical of autographic printed matter—a pleasant grittiness to the tones and a rich sheen to the shadows, coupled with very pure highlight tones. The edges of the light to dark tonal areas tend to become exaggerated, giving the impression of increased sharpness and definition, similar to acutance effects in normal photographic processing. All these image qualities combine to give a feeling of overall enhanced print quality difficult to duplicate by any other form of sunprinting.

The oil process diminished in popularity with the introduction of a similar process known as *bromoil*, based on the principle of using the silver in a normal photographic print as the hardening or tanning agent

instead of exposure to daylight. The rationale of this process is due to the researches of H Farmer, E J Wall and the practical application of C Wellborne-Piper, an eminent pictorialist of his time.

Bromoil has remained popular with a small band of devoted pictorialists for a great many years, but recently it has become increasingly difficult to obtain the equipment and sensitive materials to accurately work this process. Fortunately, it is comparatively easy to make a gelatin coated paper which is the basis of oilprint-making.

Basic process Oilprinting differs from the other pigment processes in the manner in which the image is manufactured. Normally, the pigment or colouring matter is contained within the colloidal layer, but with the

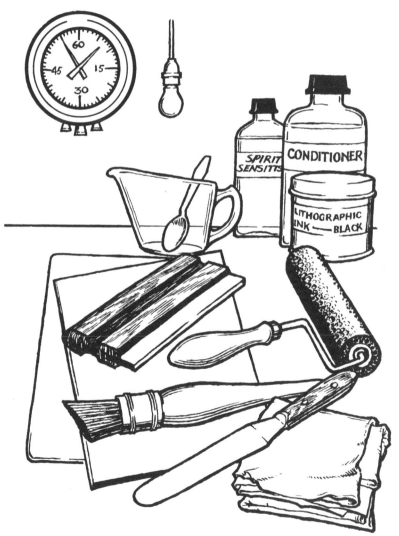

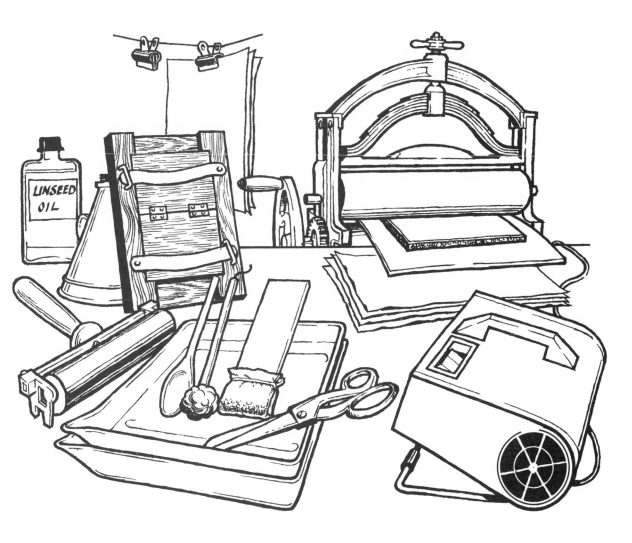

oil process the image appears on the surface of the colloid in the form
of thick, viscous, greasy ink.

The colloid, in this case an insoluble gelatin layer similar to the
binder used in nonsupercoated photographic paper, is sensitized to
daylight by the application of an ammonium bichromate solution. The
sensitized colloid is then dried, exposed and developed in exactly the
same manner as the gumprint. Considerations regarding dark reaction
and heat fogging equally apply.

On completion of development, the colloid is again dried and made
ready for conditioning. This is no more than controlled soaking. Plain
water can be used or a special conditioning bath made up. When the
conditioning bath has swollen the gelatin layer to the right degree, an
image is produced in the colloidal layer which has a variable water
holding capacity. The shadows or dark area of the print, having received

the greatest exposure, will hold the least amount of water. On the other hand, highlights of light tones will hold most water.

This variably hygroscopic image is made visible by the application of pigment in the form of a stiff lithographic ink, applied to the surface of the print or matrix as it is sometimes known. Where the matrix is heavily charged with water, that is, in the highlights, the greasy ink is more or less repelled, but in the shadow areas where there is little water present, the ink becomes firmly attached, thereby revealing an image in graduated lithographic ink.

The application of the ink to the surface of the matrix is the most critical stage of the process. It is also the most difficult if easy pigmentation is to be achieved. An accurate balance between exposure and conditioning must be sought. Special brushes are used in pigmenting which can control precisely the amount of pigment used. It is vital that these brushes be used for successful oilprints.

Oilprinting is basically a simple process but if the right balance between exposure and conditioning is not maintained, the process is very erratic, time-consuming and difficult to work. It is far better to start again from the beginning than spend hours trying to rectify faulty technique by skilled pigmentation.

Matrix base material One of the main problems in oilprinting is obtaining a gelatin coated base material suitable for the process. Originally, a paper known as double transfer, as used in the carbon printing process, was the recognised base material, but as carbon materials are now very difficult to obtain, substitutes must be found.

Normal photographic paper is useless, as it is supercoated and includes hardening agents. Most matt photographic papers, such as Kentmere's art document photographic paper, can be used as they are nonsupercoated. Unfortunately, these papers contain a high proportion of starch grains to give the matt look to the surface of the paper, resulting in a gelatin layer which is very thin and dry to work with.

Ideally, the matrix should be rich in gelatin which is only just insoluble, very soft and jelly-like in character, so that, when conditioned, it holds a great deal of water in the highlight tonal areas. A matrix in this condition will give a print of long density range rich in tonal quality.

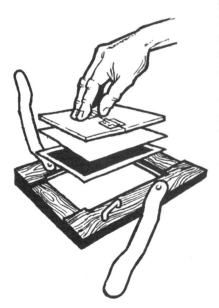

Homemade matrix material is the answer to this problem. Make a solution of approximately 15% dry cooking gelatin in hot water. Coat this gelatin solution whilst still hot onto the *back* of used photographic prints with a large paintbrush or, alternatively, a blanchard brush. Place on a level surface to cool and set, then dry in a very gentle stream of warm air at no more than 30C (86F) or the gelatin will reliquify and simply drip off the paper. Once the paper is dry, store for future use in a dry atmosphere. This material should prove to be more than adequate for the production of oilprints, but a more rugged material will need to be made for oil transfer work, owing to the fact that the

64

matrix has to pass through the press, where it can be damaged very easily.

Designers' and screenprinting tracing acetate, such as Kodatrace, provides a tough semitransparent base with tooth or texture to hold the gelatin. Being transparent, visual registration is possible and the material itself is dimensionally stable, solving some of the major problems of achieving successful registration. Nelson No. 1 gelatin powder should be used rather than cooking gelatin, as it is tougher. Together with the acetate base, it should withstand the wear and tear of the press more efficiently.

Full details of gelatin coating procedure are described in Chapter 3. It is still possible to obtain double transfer paper, but the only manufacturer is Franz Hanfstaengl of Munich, West Germany. Also manufactured there is a material called *oleography paper* which is absolutely ideal for this process. These materials are only supplied in rolls of not less than 5 meters (16 ft) in length and between 72 cm (28 in) and 112 cm (44 in) in width.

If a matt photographic paper is used as a base material for the matrix, it has to be fixed to remove the silver salt. This should be done using a 20% bath of plain hypo containing no hardening agents. On completion of fixation, give the paper one hour's wash in fresh running water. Remove the paper from the wash and carefully squeegee on both sides to remove the majority of the water, blot damp-dry with fluffless blotting paper and hang it up to dry in a stream of hot air. It is very important that there should be no free water drops on the surface of the paper as the pigmentation will be uneven if the paper is dried in this condition.

To sensitize the oil matrix base material a spirit sensitizer is used, similar to that used in the carbon process. This spirit sensitizer consists of one part 10% ammonium bichromate solution and two parts denatured alcohol or methylated spirit. The advantage of using this type of sensitizer is that drying is very rapid. Five to ten minutes should be more than adequate when the sensitized material is dried in a stream of hot air.

First, dampen the material to be sensitized with clean water, then remove all the surplus moisture and lightly squeegee onto a sheet of glass so that the gelatin layer is face-up. Take a piece of cotton wool about the size of a hen's egg and wrap around it a piece of fluffless flannel or cotton to form a pad. As an alternative, chamois leather, real or manmade, may be used without the cotton wool. Dip this pad into the spirit sensitizer, charging it full of solution, then starting at the top left hand corner of the sheet of material, stroke the pad across the sheet horizontally, then vertically, until an even yellow orange stain covers the whole of the sheet. Continue this treatment until a point is reached where the colour does not alter in density. The sensitization is now complete. Inspect the overall evenness of the bichromate stain.

Ideally, it should be perfectly even or faults similar to development marks in conventional photographic processing will occur. Remove any surplus sensitizer from the surface of the material by wringing out the pad and wiping it over the sheet.

Dry the sensitized sheet in a stream of hot air, preferably in a room in which there is a low level of artificial illumination, as the sheet is now sensitive to daylight and fogging can easily occur. When dry, the sensitized material can either be used immediately or stored for future use. Dark reaction limits the length of time it can be stored to not more than two or three days. A wise practice is to sensitize and use as soon as possible.

Exposure Exposure in oilprinting can be simply judged by the appearance of the image. A strong print-out image can be seen when the exposure is correct. Highlight detail should be just visible in the light tones of the print. The knack of using this criterion for exposure assessment is quickly learned and is almost foolproof compared with other methods, but if any doubt exists as to the accuracy of exposure, a simple test devised by Robert Demachy in the *Sinclair Handbook of Photography* published in 1913 is still valid today. He suggested that if there is any doubt on the question of exposure, try to wipe the ink off the lighter half-tones of the print with a wet pad of muslin. In the case of underexposure, the ink will be completely removed by the first stroke of the pad, leaving the gelatin surface perfectly clean. With over-exposure of the print, the ink will take a great deal of rubbing before it will leave the highlights of the print and the surface will remain spotty. This is a useful test that never fails, and has been found to be extremely reliable by the author.

The oil emulsion is slightly faster than the gum coating, because no pigment is present in the binder layer, so exposures to daylight of between two and ten minutes should prove sufficient. If the same matrix base material is always used, then a very consistent emulsion sensitivity will result, so that once the correct exposure has been found for a particular negative, it can be simply marked with the correct time of exposure. Further printmaking can then be undertaken with every chance of success.

A continuous tone negative of normal contrast and density is required. It should be of similar quality to that used with a diffused light source enlarger.

A laterally reversed negative is needed for oil transfer printing, although it is feasible to employ an offset technique where this lateral reversal is unnecessary. A smooth sheet of rubber is used to remove the ink image from the oil matrix. This offset image on the rubber blanket is then passed through the press a second time, and the image retransferred onto a sheet of paper. Some softening of definition may result from this procedure.

Development In oilprinting, development is really a form of fixation. During development, only the bichromate sensitizer is removed, the gelatin emulsion remaining insoluble.

Allow the exposed matrix to soak, face down, in a large dish filled with clean water, until the yellow bichromate stain has completely left the image. Several changes of water will help to clear the image quickly. Fresh, clean water must be used at all times. Development is complete when the shadow and middle tones of the print change colour from yellow brown and take on a greeny, grey look. Sometimes this will take up to one hour, but normally, twenty to thirty minutes should suffice.

Uneven soaking of the print during development must be avoided. It is very easy for the print to rise up out of the dish or to have air bubbles trapped on its surface. If the matrix has soaked unevenly, then it will ink equally unevenly and only a great deal of manipulative skill with the pigmenting brush will save it.

When development is complete, remove the print from the dish and squeegee off the majority of the surface water from the front and back, then damp dry with fluffless blotting paper and hang up in a stream of hot air to dry. Make sure that there is no free water on the front or back of the print, otherwise uneven pigmentation will result later on in the process.

It is vitally important that the matrix is dried thoroughly. This drying stage helps to bring the print into the right physical state for conditioning and successful pigmentation. When dry, the matrix is chemically inert and can either be stored for future printmaking, or oilprinting can be commenced immediately.

Conditioning This stage is one of the most critical of the whole process. The matrix is soaked in a bath which brings the image into its correct condition for pigmenting, that is, the gelatin matrix has to take up exactly the right amount of water to repel the greasy ink in correct proportion to the required tonality of the finished oilprint. Undersoaking or conditioning results in the ink adhering all over the image, giving a flat, dirty look to the print. With too much soaking the reverse happens—the ink will not take on the image at all, except perhaps in the shadow areas.

The conditioner consists of one part glycerine to two parts of water, plus the addition of 5% ammonia solution. The matrix is soaked for fifteen minutes in this solution to bring it into the correct condition. Slight over or underexposure can be allowed for by increasing the soaking for the overexposed matrix and decreasing the soaking for underexposure. This control must be found by trial and error. Oversoaking can only be corrected by drying. Undersoaking on the other hand, is simply corrected by cleaning off the ink from the matrix and soaking for a longer time.

The conditioner should be bottled for future use.

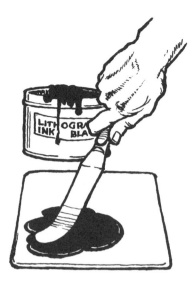

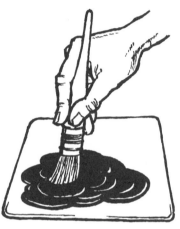

Pigmenting To pigment or ink the oil matrix, use either special brushes made for the process, or as an alternative procedure use a latex foam roller. The latter method gives a slightly coarser image quality than the brush procedure, but is very fast. It is possible to use a combination of both methods, thereby enjoying the advantages of each.

Having correctly conditioned the oil matrix, lay it face-up on a sheet of glass or formica. Remove all the surplus moisture with a chamois leather or substitute. The matrix is now ready for the ink. For brush pigmenting, start by preparing the pigment in the following manner. Take a small piece of glass or Formica and place a little ink about the size of a pea on it, then smooth it out thinly with a palette knife. Take the bromoil brush, holding it by the extreme end of the stem, so that it hangs loosely and perpendicularly. Dab the ink patch on the glass palette with the brush. Tap the brush again on the glass palette, in an area where there is no ink to remove all the surplus ink from the brush.

Still holding the brush loosely and perpendicularly, select a part of the image which has many tonal differences and lightly dab the brush in a pressing, smudging movement. At first, nothing happens except an area of ink is transferred onto the matrix, but as the brushing continues, the image begins to appear. Continue brushing until no further building of the image seems to be taking place, then recharge the brush with more ink at intervals. The secret of successful pigmenting is not to load the brush with too much ink, which will tend to destroy image detail. Work very lightly at first until the basic structure of the image is established. Then, and only then, build up contrast and ink density. Speed and manipulative skill comes with practice so do not get downhearted if your first oilprint is not perfect.

The ink may be taken up all over, from highlight to shadow, but with a contrasty subject the shadows and middle tones may ink up satisfactorily, but the highlights refuse to take the ink. In this case the ink has to be softened by the addition of either linseed oil or Robertson's medium. Only a trace of either one of these is necessary to completely change the character of the ink and, therefore, they should be added with caution. This softer ink will now take on the lighter tones.

Roller pigmenting is similar to brush pigmenting. The ink is spread on the glass palette with a small lino printing roller so that it is thin and even. This palette needs to be about 20×25 cm (8×10 in) in size. A second sheet of glass is also required. Move the foam roller over the inked sheet of glass very lightly several times, and then roll it over the clean sheet of glass. A very thin ink coating should appear on this second sheet of glass, leaving only a very small amount of ink on the roller. In this condition quickly pass the roller backwards and forwards across the matrix. The ink image quickly appears, but owing to the small amount of ink on the roller, it lacks proper contrast and density. Dampen this image with a piece of chamois leather or substitute. Then recharge the roller from the glass plate containing the ink and roll

68

directly onto the matrix. The roller, holding more ink this time, builds up the image to its full potential.

Oilprinting, using this method, is very fast and gives an image in ink which is also extremely even, owing to the smooth action of the roller, but a loss of fine detail does sometimes occur when compared with the brush method.

A mixture of brush and roller technique can prove a very useful compromise. The roller is used to build up the initial image quickly and efficiently, then the brush is used to finish the image and manipulate the densities for creative effect. This combination of inking methods is ideal for oilprinting.

Transfer The image in the oil process consists of sticky, viscous ink made of pigment, varnish and oil. This image will readily attach itself to most surfaces. The gelatin surface of the oil print will take this ink image, but only just. As there is always water present in a correctly exposed matrix, even the shadows should contain a small amount of water or the image will fail to transfer properly. But if there is just the right amount of water present in the matrix, the ink image readily leaves the gelatin surface of the oilprint and becomes attached to almost any other surface with which it has been strongly pressed into contact.

Considerable pressure is needed to transfer. An autographic etching press will therefore, be needed. This is one of the main snags in oil transfer print-making, as such a press is very expensive. However, it is still possible to pick up old Victorian cast iron mangles and if the wooden rollers are sheathed in steel piping, they prove to be excellent presses for oil transfer printing.

The original oilprint should have at least 2cm (1in) white rebate around the edge of the print. This makes pigmentation easier. Also, the transfer paper must be 2–8 cm (1–3 in) larger on each side of the material than the oil matrix, so that if the overall size of the latter is, say, 18 × 23 cm (7 × 9 in), including the rebate, then the transfer material must measure at least 23 × 28 cm (9 × 11 in). This extra paper is not a waste, but essential, as it allows ease of handling, pencil registration and makes for easy passage through the press, with less risk of crinkling, creasing and skidding which occasionally causes damage.

The matrix image will need to be much heavier in density than a normal oilprint. The highlight and middle tones transfer more easily than the shadows, therefore, the shadows will need extra ink reinforcement, or second printing of the shadow areas will be needed to achieve correct print density. Transfer is helped if the transfer paper is slightly dampened before use. A much smoother tonal image results, and this dampening eliminates any tendency for the gelatin surface of the print to adhere to the transfer paper.

As great pressure is exerted by the press in transfer printing, a pack is needed to protect the print material from damage. The matrix is

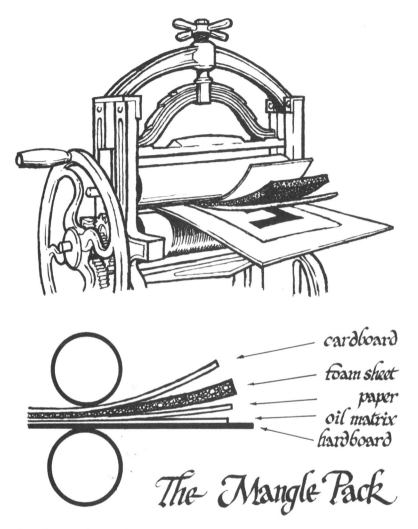

cardboard
foam sheet
paper
oil matrix
hardboard

The Mangle Pack

placed on a sheet of stout cardboard or hardboard, the transfer paper is placed on top of the matrix, then a half inch sheet of latex foam rubber is placed on top of the transfer paper. Another sheet of stout cardboard completes the pack. These sheets should be twice as long as the work, so that there is always one side ready for printing without the necessity of removing the pack from the press.

Problems of registration occur due to the extreme pressure employed in the transfer process. However, with careful work and choice of transfer materials the main problems of transfer can be overcome. Use strong and dimensionally stable oilprint matrix material. The transfer paper should be of high quality and handmade; etching papers containing rag rather than wood pulp are well-suited to this process.

When using a commercially prepared paper (such as that manufactured by Kentmere) as a matrix base material, successful registration

70

is accomplished by passing the uninked matrix through the press several times without the transfer paper. Having done this, ink up the matrix and run both the transfer paper and inked matrix through the press. Remove the matrix/transfer paper sandwich from the press, rule four pencil strokes across the back of the matrix and transfer paper, so that one stroke is located on each of the four edges of the print, then strip the two apart. If further printing is needed, registration is simply obtained by realigning the pencil marks of the matrix. If either of the prints has stretched out of shape during the printing, realign from the centre of the print, so that this lack of registration is minimized.

Drying An oil transfer print dries almost as soon as it comes off the press, but an oilprint takes quite a long time to dry. The surface of the print will remain tacky for the best part of a day before it begins to dry. In this tacky condition the print is liable to pick up dust, so make sure it dries in as dust-free an atmosphere as possible. When dry, the print can go through a process known as *defatting*, that is to say the oily sheen which is characteristic of this process can be removed to give a matt surface similar to a gumprint. To defat the print very carefully slide it into a bath of carbon tetrachloride (this is a toxic chemical and must be used with caution in a well-ventilated room) and allow it to rest there for twenty to thirty seconds, then gently remove it and place on a flat level surface to dry. Do not hang up the print to dry, as this could cause the ink to run and spoil the print. Many feel that this extra process of defatting is not worthwhile. If a matt print is required, it is more sensible to make a gumprint in the first place.

Conclusion The print can be seen as a unique creative experience in its own right, and not just as a technical extension of the picture-making process. The photograph, an image projected by a camera lens and recorded on lightsensitive material by photochemical action, can be regarded as only a starting point for further creative exploration and discovery.

A painter will quite often turn to autographic methods of printmaking to more fully develop ideas conceived while painting. While still retaining the picture qualities created spontaneously by mental and/or emotional stimuli he will now ruthlessly separate and simplify this painting into its basic tones, colours and picture elements. Then, by analysis and deliberate reconstruction, give birth to a completely new image, born, like the phoenix, from the ashes of the original creation.

The photographer can, by using an analagous approach to creative sunprinting, recreate a photograph in the same manner as the painter recreates his painting into an autographic print. The photographer has to be completely ruthless in breaking down the image into its essential parts. If the oil transfer printer is honest in his appraisal and reconstruction of the original picture, then a new and more virile graphic image will result.

There are technical problems associated with this type of creative image-making. Oil transfer printing is a slow and laborious task. The printing matrix must be brought into exact hygroscopic balance with the viscosity of the ink. The ink itself is very messy to work with. Brush inking requires a considerable amount of manipulative skill and is very time consuming. Even a small print can take up to an hour to complete. Oil transfer may need heavy and expensive printing machinery to work the process efficiently. This machinery immediately causes other problems such as accurate registration and the possibility of mechanical damage. It is a very frustrating experience to watch the best oilprint you have ever inked being mashed into a pulp by the press. However, with slow, patient work all these problems can be solved.

This process is a ruminative form of creative photography, not 'the decisive moment' kind or that in which the camera probes the spatial fractions of time. Images are understood as a series of creative acts and decisions, accumulating into a single eloquent statement. The slow working method of this way of print-making, although frustrating, imposes its own discipline and provides generous rewards for the dedicated print-maker. As in Aesop's famous fable, the slow turtle often, in the end, vanquishes the faster hare.

The process is capable of a strange magnetic beauty, strongly graphic, with vibrant shadow detail alive with oil pigment, middle tones which are fully saturated and of very pure colour, and pastel highlights of extreme delicacy.

4. Colour in Sunpictures

Introduction Colour is magical to work with, and the sunprinter employing coloured dyes, metals or pigments as part of the image making process for the first time, will find it an enchanting experience.

The creative sunprinter must handle colour with great care for it contains powerful visual energy, and can easily become gaudy and vulgar, or conversely, drab and boring, if not handled with the right degree of sensitivity. Colour can heighten emotional response. Individual colours have various symbolic meanings associated with them. Red, for instance, can either be the colour of warmth and protection, or the colour of danger, hate and shame. Different cultures and races associate completely different colours with the same experience. Death, for example, can be signifed by white, black, yellow or purple.

Creative sunprinting provides a cheap, flexible print system in which the potential of colour as a means of expression can be exploited. For example, monochrome negatives are easily converted into colour prints via sunprinting. This transposition can take the form of a slight colouration or tint to the grey tones of a print, or dramatic conversion of these tones to pure saturated colour.

Derivative photographic images also offer an almost unlimited scope for colour experiment. Drop-tone, colour posterization, linear outline effects and pseudo-solarization show remarkable changes of image quality when converted into colour. A strange metamorphosis takes place. Areas of subtle tonal gradation are transferred into flat colour areas or lines. The images immediately take on bizarre forms, totally abstract in character. Mutation may then be heaped upon mutation until all semblance of reality is lost.

Although colour cannot be said to have a physical dimension, it certainly adds a vertical subjective dimension to the picture. This vertical dimension of colour sets the mood and can translate subtle information in many different ways. For instance, the change in the seasons is reflected as a change of colour and coloured light; the rich ripe

colours of autumn pass into the quiet, mysterious tones and colours of winter. In spring there is a sudden burst of fresh colour which develops into the vibrant strength of the colours of high summer. Similarly, each part of the day has its separate ambient colour mood.

Trichromatic colour One of the simplest techniques for the production of a multicoloured print is the employment of the trichromatic principle. This mechanism of colour printmaking is often difficult for the beginner to understand.

When mixing *pigment colour*, three colours are usually used to start with—yellow, red and blue. From these three, a vast range of other colours is easily made by mixing any two or three of the colours together. For instance, blue mixed with yellow produces a green hue. If blue plus yellow plus red are mixed equally, a dark brown should be produced. As the quantity of colour changes within the mixture, so does the resultant colour. Minute changes in the mixture balance produce quite strong deviations of saturation, brightness and hue in the final colour scheme.

This ability to produce a wide range of colour from three basic colours is the principle that underlies all modern colourprint systems. In photographic processes dyes are normally used as the image colourants, mainly because of their high saturation and transparency.

Yellow, red and blue are the *artist's primary colours*, whereas yellow, magenta and cyan are the usual *photographic primary colours*. The yellow is self-explanatory, the magenta describes a particular purple and the cyan a greeny-blue, rather similar to a turquoise in hue. There are good reasons why these colours are used, but to delve deeply into subtractive and additive colour theory would not help the novice sunprinter. For those interested in colour theory, there are a number of excellent books on the subject (*see* Bibliography).

At this stage a useful exercise for the beginner is to obtain some yellow, scarlet or magenta, and cyan chinese or cerulean blue dye, oil or water colour pigment and make a colour circle. This circle is not only useful for a thorough understanding of the chromatic balance of the three *primaries* yellow, magenta and cyan, but also the *secondary* colours of blue, green and red, as well as the *tertiary* colours, typical of which are the sepias, browns and olive greens.

This colour circle is extremely useful and is an invaluable aid to the understanding and achievement of accurate chromatic balance. The secondary colours are mixed by taking equal parts of two of the primaries, and the tertiary colours are produced by varying the proportions of the three primaries in the mixture. By observing the overall colour caste produced, the tertiary colour is placed adjacent to the nearest primary or secondary colour that appears to relate most chromatically to it. Where a tertiary colour seems to relate equally to both a primary and a secondary colour, then it should be placed between each of these

colours. In this way, the colour circle is built up and the basic interrelationships of colours are understood.

The trichromatic system has made possible the modern colour integral tripack which is used in all current photographic materials. The tripack consists of three colour producing layers, stacked on top of each other, which together produce the colour image.

The degree of mechanical and chemical sophistication that this feat of technology requires is completely beyond the capabilities of the creative sunprinter, but it is quite possible to use the colour print or preferably the colour transparency as a starting point for creative trichromatic printmaking, via simple monochromatic colour separation techniques. Some of the dye and pigment processes respond to multi-image assemblage, and have been used for such a purpose in the past, with dye transfer still being employed where high fidelity colour is required.

Although the trichromatic method has much to recommend it, being highly suitable for large scale commercial production, it has many disadvantages from the creative printmaker's point of view. The main weakness stems paradoxically from the basic simplicity of the process, because a great many colours and tones have to be produced from essentially only three images in perfect register, made up of yellow, magenta and cyan dye. Therefore, the balance of image densities and contrast in relationship to the original scene or colour transparency must be extremely precise. This requirement leads inevitably to a high degree of technical complexity during the processing stages. However, this is a soluble problem compared to the main creative objections, which are that creative control over individual colour areas within the picture becomes a task of extreme complexity. A third and final objection is that the purity of the colour print is far from ideal and allows very little change in surface quality of the colour image. Therefore, the use of the trichromatic principle requires acceptance of a standardized product of moderate colour quality, allowing little or no flexibility of creative control.

Often the lack of colour purity in modern colour materials is overlooked until the colour photograph is directly compared to the original scene or transparency, when it will become readily apparent. A certain amount of correction is possible by the use of complex masking technique, but the problem of surface quality and control over individual colour areas remains.

Flat colour assemblage This is an approach to colour printmaking, radically different from the trichromatic synthesis. It is partly subtractive, but differs in the first principle; it relies on horizontal colour rather than the vertical colour of the former system. To explain this principle let us say a landscape consisting mainly of green fields is to be printed employing the trichromatic system. To print the green fields, two strong

images of cyan and yellow, plus a weak image of magenta, would be required. The cyan and yellow produce the green secondary colour and the magenta darkens the image and emphasizes the tonal range within the green colour area. Each of the images is printed one down upon another in register. Flat colour assemblage, on the other hand, needs only two printings to produce the same landscape, one to give the range of grey tones and the other to provide the green colour.

In theory, the trichromatic method should give far more accurate colour as the relative cyan and yellow colours should give a greater variety of green hue. In fact, however, because of imperfect dyes and the impossibility of exactly matching three layers of dye to synthesize the exact colour required, the cruder method of flat colour assemblage is more likely to produce an acceptable colour. The overall colour of the green can be very precisely adjusted by careful colour mixing before it is printed, to match the final colour requirement of the image. In other words, the colour is mixed on the palette and not on the picture as in the trichromatic process. This premixing of colour supplies the degree of creative colour control missing in conventional three-colour printmaking technique.

Problems arise using this method of printing for a multicoloured subject. The answer is simple where two or three colour areas are adjacent to each other. They are all printed separately, one at a time or at the same time, the latter only being possible if the adjacent colours do not interfere with each other. There are, however, limitations to this form of printing. It cannot deal effectively with a multitextural colour subject such as a bed of mixed flowers or the chaotic colour of the funfair or amusement arcade. However, this type of textural colour is rarely encountered and seldom makes satisfying creative colour compositions. The fact that the photographer is in the position of adding or subtracting colour almost at will, allows for full creative exploration and the breaking of the constraints of the trichromatic process.

The number of separations that are printed is limited only by the nature of the sunprinting processes and the technical virtuosity of the sunprinter himself. With careful coating a number of colour areas are easily printed at the same time, thereby shortening printing time. Colour quality in a print is quite often in direct proportion to the number of printings, each printing producing an additional richness and depth to the image.

Fine art print-makers such as lithographers, etchers and lino/woodcut printers have for centuries used a form of flat colour assemblage, first making a colour drawing, then from this producing an outline or key drawing of the colour areas which, in their turn, are converted into separate printing blocks, or printing plates. Each plate is then printed with the relevant colour onto a sheet of high quality paper, exactly in register with the previous colour. The light colours are printed first, followed by the saturated middle tone colours. Finally, the whole print

is pulled together by application of the shadow block which completes the tonal range of the print.

This system of print-making probably evolved from the classical manner of oil painting in which a drawing is made on the canvas, brightly coloured areas are painted in fairly large blocks of colour and then the tonal passages are gradually painted in until the darkest shadow is reached and the painting is complete.

The single colour separations in flat colour assemblage can be produced either by autographic or photographic methods. The photographic separations are effected by making home-produced colour filters, simply manufactured by dyeing fixed out photographic film. For example, a landscape which contains blue sky and green fields and foliage only, will need two colour separations and one black or tonal range printer. Firstly, the blue sky printer is produced by using a gelatin filter which is complementary or opposite in colour to the blue sky. The colour circle is consulted and blue sky colour is found to be an opposite colour to yellow. Therefore, a yellow filter is placed in front of the camera lens and a correct exposure is made onto panchromatic film. The negative produced has received no blue light, due to the absorption of the yellow filter and, therefore, shows zero density in the blue regions of the negative. As these areas are clear on the negative, they should print as maximum blue density when applied to the positive colour separation. The green foliage needs the opposite colour to green, which is primary magenta, to produce an equivalent effect. The black printer is made by making a normal monochrome negative without any filtration. The autographic method is to draw in the colour area on tracing paper or Kodatrace, employing methods fully described on page 000.

An elegant and extremely simple alternative to the drawn or autographic negative is to make a negative colour separation by first drawing in the colour area with photopake. This is achieved by the use of brush and/or ruling pen onto either tracing paper or Kodatrace. This opaque positive colour separation is contact printed onto high contrast film such as line or lith. The exposure is adjusted so that maximum density is obtained in the nonprinting areas of the negative separation. This negative separation should show only clear film in the colour areas and opaque film in the non-colour areas. The tonal gradation within the colour area is achieved by binding up the black printer negative with the colour separation negative. In this way the lighter tonal areas are reproduced faithfully within the colour areas. Obviously both the black printer and the negative colour separation must be placed in perfect registration in relationship to the original colour picture. The black printer is used in turn with each colour negative separation. It is surprising how easy it is to produce these opaque autographic separations and the creative potential inherent in this technique is enormous. Ordinary carpet or cloth dyestuffs are suitable for the manufacture of the homemade filters. To find the most suitable dye a number of closely

related colours may be used. For the example of the blue sky, discussed previously, these might be yellow, mid yellow, egg yellow, and lemon yellow. When the scene is viewed through these homemade filters the filter which shows the blue sky as a darker tone than the rest will be the most efficient. This filter has to isolate only one colour, not a band of colours, as with a trichromatic filter. A great deal of latitude is therefore implicit in this form of filtration.

Flat colour assemblage is not just an alternative to trichromatic print-making. It allows direct positive control of the image colouration and precisely controlled colour hue, which can easily be matched to the adjacent hue in a highly creative way.

Colour appreciation To fully appreciate colour, the relationship between the tonal range of a picture and the actual areas of colour must be fully understood. The tonal range of a picture, that is, the gradation of tones from pure white through to pure black, defines the picture subject matter. It gives the required visual information necessary for the mental understanding of the picture.

Two-dimensional representation is, after all, an abstraction from the reality of a three-dimensional world where sight, sound, smell, taste, movement and the passage of time all work in unison to provide us with our personal concept of reality.

Tonality provides the key to the control of creative colour. The power of tone is seen in colour pictures which employ a technique of colour economy. For instance, take the example of a brown egg in a white bowl containing other white eggs. The whites and light grey tones make the brown of the single egg literally shout with vibrant colour. Another example is the use of so-called monochromasia, when the appeal of the colour composition lies in the use of a single colour overlying differing shades of grey and desaturated complementary colour; the soft green tones of water lilies floating on a green algae covered pond, the blue-greens of a distant seascape, or the rust reds of a pile of scrap iron or mild steel, all provide examples of close order colour relationship where tone vitalizes the colour values.

As the tonal range of a picture becomes stronger, the colour recedes as a visual force. An interesting practical exercise can be performed by selecting a moderately colourful landscape subject and taking two photographs of it, one on a dull misty day and the other on a day when bright direct sunlight illuminates the scene. Although the softer lighting conditions will not give as bright a colour, the overall colour composition is often far more effective than that of the brightly lit scene. The reason for this is that the colour values are in direct visual competition with the lighting contrast of the scene. The creative sunprinter should always try to keep an harmonious compositional balance between these two powerful visual forces.

Once this relationship between tonality and chromaticity is clearly

understood, a whole new world is seen. Dull weather is no longer shunned. The dull misty days of winter hold exciting possibilities for the creative colour worker. There is subtle colour beauty in the wet blue-indigo of a tiled roof and the pastel shades of autumn leaves on an icy fog-ridden morning, to cite only two examples of a limitless range of subject matter just waiting for creative exploitation.

The perception of depth depends on three separate illusions. The first illusion is optical and depends on the fact that the eye works on exactly the same principle as a camera lens. Objects in the foreground of the picture appear to be larger than exactly the same sized object in the background. The second illusion of depth, described as aerial perspective, is based on the way tonal values change from the foreground, through middle distances into the background. The tone is seen to lighten as it recedes into the distance. The third and final illusion depends on colour relationship. Some colours are generally considered to be warm when compared to others. Reds, oranges and yellows have warmth whereas blues, blue/greys and greens are said to be cold in colour value. Cold colours seem to recede in the picture plane, and conversely, warm colours advance.

This principle of the comparative warmth of colours can be refined still further. A single colour is said to be either warm, cold or neutral. For instance, a yellow green is warm compared to its reciprocal blue green. A green that has a colour value which places it exactly between these warm and cold green hues is said to be neutral, neither hot nor cold.

These fine differences in colour warmth allow very sensitive adjustments in colour value and add another weapon to the arsenal which is employed to control creative colour in sunprinting.

It is useful as a help in understanding warm and cold colour schemes to build up a reference book of colour composition examples from which future inspiration is sought. This personal research is discussed in Chapter 8. Colour appreciation, like any other form of appreciation or judgement, must be based on sound knowledge and understanding, not just on superficial feelings.

Colour composition is both complex and an essential step in the process of picture making. Most beginners in colour photography take the photographs as if they were black and white pictures which just happen to contain colour, in other words, the typical snapshot. The author has no wish to denigrate or sneer at the beginner. On the contrary, the whole object of this book is to whet the appetite of the beginner in this fascinating area of creative study. The inability of the beginner to see colour relationship is normal. There is a bridge that has to be crossed. On one side of the bridge there is little or no concise understanding of colour relationships. Although a person may have extremely good colour taste, this knowledge tends to be subconscious. At the other side of the bridge, colour awareness is awakened.

Colour must be recognized in its own right; a potent visual force. The mind needs disciplining to consciously recognize one colour in relationship to another. The beginner will be amazed at the insistent way the mind refuses to remember or become conscious of colour. The underlying reason for this difficulty in remembering may be because colour is to a large extent emotional in its visual effect.

The only way to cross this bridge of colour awareness is by very careful study of the basics of colour composition. As a start, expose a few rolls of colour slide material using a single coloured object such as a lemon, orange or any brightly coloured object. Photograph this single object on black, white and grey background paper using daylight, not direct sunlight.

Take the next series of photographs, in exactly the same way, of an object which has a complementary colour hue to that of the first object. Ideally, this object should not be brightly coloured, i.e. desaturated. The primary object's colour must still dominate the picture. For example, if the first object was yellow the secondary colour is blue and a light or dark blue object should be included in the composition. Make a final set of exposures. This time the tertiary colour is brought into the colour composition, one exposure using sepia, one exposure using olive green and the final exposure using a dark red purple. Coloured background papers could be employed to achieve the inclusion of the tertiary colours. This is the way to explore the basic composition of the six colours of the colour circle, yellow, magenta, cyan, blue, green and red. Give each colour the treatment as described, in a carefully controlled manner, until a complete orchestration of colour is achieved.

Once these series of colour compositions have been completed, study all of the slides and see how each primary colour relates to each of its secondary and tertiary colours. Think colour. Become aware of the feel and the mood of the differing colour arrangements. If the beginner has the patience to successfully complete this series of colour experiments, the bridge of colour awareness is crossed and the way is open on the long road towards the mastery of colour as a creative visual force.

5. Sunpictures in Metal

Introduction The first sunpictures had light sensitive silver metal as the basis of the image. This metallic silver laid the foundation of photography as we know it today.

A number of metals or metallic compounds show a remarkable ability to darken when exposed to light. Apart from silver, light sensitivity is shown by platinum, iron, uranium, mercury and the heavy elements of cobolt, tungsten, radium, molybdenum, cerium and nickel.

Prints which use metals as light-sensitive constituents often exhibit a smooth tonal range and lustrous appearance very superior to alternative sunprinting processes. The metallic print has a soft, rich surface quality coupled to a range of colour which is deep and earthlike.

The dye processes sparkle with vivid colour, bright and deeply saturated, sometimes to the point of gaudiness. On the other hand, the pigment processes have great virtuosity, ranging from the pale and delicate to the strong and dramatic.

Images in metal, however, exhibit a dignified quiet charm; satisfying, and at the same time mysterious—further creative puzzles for the sunprinter to solve.

A great choice of colour is possible with these processes, either as the initial colour or by a process of metallic toning similar to normal photographic toning. The correct choice of base material is most important. If paper is to be employed as a base material it must be of the highest quality, chemically pure and containing no trace elements. Sizing is quite often necessary, and this operation must also be handled with care. Too much sizing and a thin desaturated print results, too little and the light-sensitive coating disappears into the fibres of the paper. The size sometimes contains vital chemistry needed to successfully work the process, at other times no size is needed. It depends on the nature of the metallic compound and the absorbency of the paper.

Although paper is ideal as a base material, other bases can also be employed. All that is needed is a substratum of either gelatin or

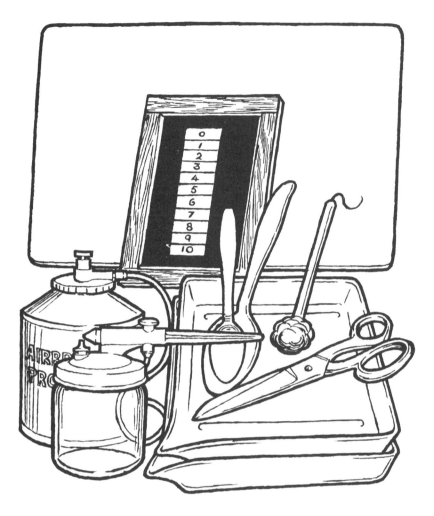

albumen, then canvas, glass, porcelain, or even ceramic tiles can hold a picture in metal. Where the base is of high absorbency, such as fabric, the best substratum is soft gelatin. Non-absorbent surfaces present a difficult problem as the size cannot sink in, therefore, a thin film of albumen (egg white) should be applied which is then able to take up the light-sensitive coating to the right degree. The albumen layer must be dried first before sensitization to the metallic compound, usually in the form of an aqueous solution. The sized base material is then floated onto or into this sensitizing solution.

Use of metallic light-sensitive compounds does present some problems. Most of these chemicals are extremely fugitive by nature, liable to discolour, stain and fade when submitted to continuous exposure to light or aerial sulphide gases. Contamination during processing can present many dangers. Metallic substances like rust or traces of other metallic compounds must be guarded against. Cleanliness and the use

82

of non-metallic processing equipment will help to cut down the risk of contamination. Process with plastic, glass or earthenware utensils.

Toxicity is another problem. Most of the metallic substances employed in this section are poisonous if swallowed, so great care is required in the handling of these substances. *Rubber gloves are essential basic equipment*. However, with care and attention to normal darkroom discipline, no real problems should occur.

Metallic processes differ from other forms of sunprinting in that the light sensitizer is quite often the emulsion rather than a combination of sensitizer, binder and colourant, more usual in other processes. One of the great advantages of sunprinting in metal is that the processes tend to be extremely simple to operate and do not require the skilful manipulation needed in some of the other areas. It is a comparatively easy task to quickly make a sunprint.

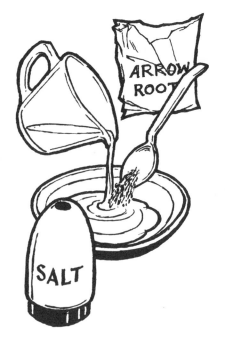

SILVER SALT

History The salted paper was invented by the father of modern photography, William Henry Fox Talbot, who first worked this material to produce paper negatives at Laycock Abbey in 1835. This salted paper process was eventually patented in 1840 as an integral part of his calotype process.

The paper was immersed in a weak solution of common salt, dried, and then just before use, sensitized by immersion in a solution of silver nitrate. When dry, this paper was sunprinted in contact with a continuous tone negative of moderately high contrast. The exposure was judged by inspection and the print taken slightly darker than finally required, as a slight bleaching occurred on drying. The print was next toned in a gold toning solution, the objective of which was twofold. First, the toning solution improved the colour of the black and secondly it made the print more stable to the effects of ageing and chemical contamination. The print was then fixed in a solution of sodium thiosulphate. As these papers formed a visible image during the printing process, they became known as printing-out paper or POP for short, to distinguish them from the later developing-out papers, which are still in current use today.

POP papers have long since disappeared from the photographic market. Modern developing-out papers print out but produce poor quality in the shadow tones, rarely reaching more than middle grey instead of a black tone. The reason for this is that potassium bromide is used as a salt instead of sodium chloride, because it produces a more sensitive paper.

Salted papers originally only contained silver salt held in the fibres of the paper, but soon arrowroot was added to stop the emulsion penetrating too deeply into these fibres.

Albumen was later added to the salting solution to give the paper a gloss finish and to keep the silver salts on the surface, also improving image definition. Soon, albumen coated paper was available commercially and the photographer sensitized it in a solution of silver nitrate just before use. In the middle 1880s gelatin replaced albumen, and allowed the production of a paper coated and presensitized so that it could be sold ready for printing.

The POP gradually gave way to the developing-out paper, due to its increased paper speed and superior image quality. In this way sunprinting was superseded by darkroom contact printing and finally projection printing or enlarging as it is more commonly known today.

Although the evolution of photographic paper can be seen as an inevitable progression, much has been lost. A comment by a contributor to an American publication, *Anthoney's Photographic Bulletin* of 1894 by Mr C H Clarke of Kansas City, makes interesting reading: 'Of the many beautiful printing processes now in use, there is no certainty that

any will still be in general use half a century hence. I, for one, scarcely believe that there will be, except for one of the oldest methods which most certainly must endure, although it has been sadly neglected of late, indeed almost lost sight of. The method I refer to is no more or less than the modest little plain paper silver print, which enjoys the distinction of forming the foundation of almost every other process now in vogue. To my mind there is no process known which is so easy to manipulate or which gives such uniformly beautiful results, as the plain silver print. It is as far ahead of albumen and kindred methods as the sun outranks the moon in brilliancy. The only thing that in any degree approaches it is the platinotype, and technically speaking, it is the same thing, except that platinum instead of silver is used for sensitizing purposes.' A prophetic voice from the past. Unfortunately, the plain little silver salted print has not survived either. The onslaught of technological and commercial progress has been too strong. However, the wheel is turning, and interest in historical processes continues to increase. More and more seemingly obsolete printing processes are finding favour for use in advanced work in the photographic arts.

Basic process In this process the original surface of the paper is preserved, the sensitive salt being more or less in the fibres of the paper, whereas in other processes they are suspended in an emulsion or binder. In all cases, however, a size must be used to prevent too deep a penetration into the paper. Various sizes can be used. Starches such as arrowroot, or even gelatin are perfectly suitable. The size may cause colour changes in the final print—arrowroot tends to give a brown-black, whereas gelatin gives a blue-black. The size may be applied to the paper first, but it is frequently more convenient to incorporate salts with it.

The preliminary emulsion is prepared by mixing the arrowroot into a cream with a little water. Bring the remainder of the water to a boil and add the arrowroot cream slowly with constant stirring. Continue heating until a clear jelly is formed then dissolve the potassium or ammonium chloride in a small amount of water and add to the arrowroot mixing thoroughly. Sometimes effervescence takes place when mixing the chemicals into the arrowroot jelly, so allow for this by mixing in a large measure. The arrowroot mixture is strained through fine muslin while still hot. Immerse the paper in the warm solution for five minutes and hang up to dry in a stream of warm air. When nearly dry, immerse for a second time and hang up to dry by the opposite corner to that previously used.

When dry, the paper can either be stored for future printing or sensitized immediately. After the paper has been sized and salted either float it onto a solution of silver nitrate or brush over with sensitizer with a buckle or blanchard brush. Brushing is recommended rather than floating when plain paper is to be sensitized. Dry the paper and

use it immediately, as it deteriorates very quickly, sometimes within a few hours of sensitization. Expose the sensitized paper under a fairly contrasty negative by the employment of standard sunprinting technique. Judge the progress of the exposure visually. The print should be slightly darker than normally required for viewing. Then wash it in repeated changes of water until no milkiness is seen in the water, or alternatively, a 5% solution of sodium chloride can be used and the print washed for a further ten minutes.

Toning in a weak gold chloride bath is the next step. The toning bath should contain about 1 part of gold to 10,000 of water. By varying the constituents of this bath, the image colour changes from sepia to purple-black. Platinum is an alternative to gold but it is extremely expensive. Finally, the print is immersed in a 1% solution of common salt to stop the toning action, and fixed in a 5% solution of sodium thiosulphate. It is then well washed—if archival keeping qualities are required, hypo elimination is the recommended procedure. The print is then dried. Contrast of the print can be controlled by adding to the original size coating. A small quantity of potassium bichromate gives more brilliance and sodium phosphate gives softer effects. The sensitizing and drying of the print material must be done under red safelights. Ideally, the sensitized paper should be dried in complete darkness but, if hot air is used, it should dry quickly enough to be safe under the red safelights.

Conclusion The plain silver print, long neglected, has much to offer. It resembles a fine art etching in which a very fine aquatint has been worked. It gives the same type of picture as that of an image within the paper texture itself, producing lustre and life in the print.

One of the great bonuses in the exploitation of this simple homemade silver print process is the sheer range and beauty of the possible tonal colour. Rich red, blue and purple tones, deep browns and bronzed sepias are possible with but a slight adjustment of the chemistry of the processes. The character of these tints and shades make the plain silver print a pleasure to view.

THE IRON PROCESSES

History Sir John Herschel, an early pioneer in photography, invented in 1842, the ferroprussiate process, which used organic salts of iron as the basis of a light-sensitive printing process. Herschel made a number of contributions to the early development of photography, the most notable of which was the use of hypo or sodium thiosulphate as a fixative in the silver processes. The lack of a suitable fixer had held up the successful progress of photography for a number of years. Even the word 'photography' and the terms 'negative' and 'positive' are said to be his invention.

86

A number of processes using organic iron salts emerged. The kalli-type process, which employed silver in combination with the ferric salts and the platinotype or the platinum process, as the name implies had a platinum base to the image.

In addition, organic iron salts can be made to tan or harden gelatin in a similar manner to the bichromates, but these reactions are beyond the scope of this book. The iron salt processes are based on the reduction of ferric salts of organic compound (citric, oxalic, etc.) to the ferrous state by exposure to ultra-violet or blue light.

The ferrous salt will combine with potassium ferricyanide to form prussian blue, sometimes termed Turnbull's blue.

Differing formulae give a range of blues varying from prussian blue to a bright cyan blue-green. In fact, the latter colour was often employed as the first base tricolour image in trichrome gumprinting. This process is known as the ferroprussiate process or blueprint. When combined with silver salts it reduces those salts to metallic silver, giving a rich brown image in the case of the Van Dyke or sepia paper process, or a brown-black as in the kallitype process. Platinum and palladium salts are reduced in a similar manner to silver salts and give an extremely stable image which is neutral black when platinum salt is used and warm black when palladium is used. These processes are known as platinotype and palladotype respectively. All the iron processes suffer very badly from damp and humidity. The paper must be kept very dry. Make sure that the paper is coated and printed almost immediately, then few problems will occur. Chemical contamination must be guarded against, and the paper stock should be as pure as possible. Once again, cleanliness is of great importance in any of the metallic sunprinting processes.

Basic processes The ferroprussiate or blueprint process is one of the simplest and most economic of the metallic sunprinting methods. In addition, it gives a most pleasing, bright, clear, blue image, known as the *blueprint*. It has mainly been employed as a reprographic method of duplicating mechanical drawing because it is cheap and simple to use. Commercial blueprint paper is still available but is fast disappearing in favour of dyeline, xerox and other faster working reprographic systems.

To the sunprinter coating of the ferroprussiate emulsion is child's play. A solution of ferric ammonium citrate and a solution of potassium ferricyanide are mixed together. This should be done just before coating as the combined solution does not keep. This final solution is either floated or quickly brushed onto the paper and dried immediately, pref-erably by radiant heat. This coating is sensitive only to blue light, therefore, a yellow or red safelight can be used. The emulsion must be coated in darkroom conditions.

This paper gives a direct print-out image. Judge the exposure visually.

Take the image slightly darker than finally required, as it appears a fraction lighter when dry. Fix the print in several changes of clean water until the whites clear. The last wash water bath should contain a few drops of hydrochloric acid. This helps to clear the highlights which are sometimes liable to stain.

The contrast of this process is fairly high so normal contrast negatives, as used in conventional printing, should print more or less correctly. Greater contrast in the print is obtained by adding 1% to 2% potassium bichromate to the sensitizing solution.

As a process, the blueprint has seldom been used for creative print-making, yet the beauty of the image, coupled with the simplicity of the method, should have encouraged greater use. Henri Le Secq employed the process in a conventional manner to record Parisian gothic structures for the French Government at the turn of the century. The 'Linked Ring' pictorialist, Clarence White, famous for his very sensitive and evocative portraiture of women and children, often used this process. Generally, however, it fell into disrepute, like so many other processes, with the advent of the mass-produced gelatin developing-out paper which could be toned a very similar blue.

The Van Dyke or sepia print Silver salt is used in conjunction with organic ferric salts to produce an image in a rich, dark brown of a similar shade to the artist Van Dyke's pigment from which it derives its name. This process was originally used to print menus and cheap christmas cards, and still has applications in the reprographic industry.

The emulsion is made up of ferric ammonium citrate (green scales), oxalic acid and silver nitrate. Allow 24 hours before use as the silver nitrate takes time to dissolve. This coating is sensitive to blue light only and can be prepared under yellow or red safelights. Weak artificial light is also suitable as long as the coating procedure is not prolonged, but the coated paper must be dried in the dark, when it will become fully sensitive to light.

Coat and expose by normal sunprinting technique, bearing in mind the problems associated with chemical contamination and dampness. The exposure should be such that the print is slightly weaker than is finally desired, as some intensification takes place during fixation. Following exposure, the print is placed in a weak borax bath (5% to 10%), then directly into a fixing solution made up of 20% sodium thiosulphate. The final colour is formed during fixation. After fixation the print is thoroughly washed and dried. Where a print is required for archival purposes, the use of a hypo elimination bath, after washing, is highly recommended.

Platinotype This process occupies a remarkable place in the history of photography for two main reasons. Firstly, the final image consists almost entirely of platinum metal, which is one of the most stable

elements known to man. It imparts this feature to platinotype print so that it does not suffer from the problems of image instability associated with other metallic processes. The Royal Photographic Society has many superb examples of platinotypes in its permanent collection, which exhibit little or no chemical change, after more than a century and should last for many centuries to come.

Unfortunately, platinum is an extremely rare and costly metal, worth many times the price of gold. Commercial papers were available from the 1880s made by the Platinotype Company until they became too expensive for the competitive market, and they were discontinued before the second world war.

The second reason why the platinotype is so important in the history of photography is the sheer quality of the process. The platinotype exhibits a kind of print quality lost to us today. Modern photographic print materials are manufactured to show strong neutral blacks and razor sharp tonality. Conversely, the platinotype has a soft, luminosity in the tones. The more you look, the more you see. The Photo-Secessionist masters also exploited this process, great photographers such as Edward Steichen, Frederick Evans, Clarence White, and perhaps the greatest of them all, Alvin Langdon Coburn. Gumprinting was often used to strengthen the shadows and create duotone effects. This technique, when in the hands of Coburn, produced imagery of indescribable quality and imagination.

Platinum, like the carbon process, has essentially good tonal reproduction, allowing for accurate shadow and highlight detail. The negative required for this process should be slightly more contrasty than normal, but must contain well separated highlight detail. Overexposure and/or overdevelopment is to be avoided at all costs. The platinotype emulsion is compounded of chemicals that dissolve slowly at normal room temperature. Therefore, they must be heated to approximately 38C (100F) by the use of a water bath. Even then, allow at least one hour for the chemicals to dissolve. Then wait for 24 hours before working the emulsion. The emulsion is compounded of a mixture of oxalic acid, ferric oxalate, potassium chlorate and potassium chloroplatinite. Distilled water is an essential part of these solutions, normal tap water is too impure. The emulsion is mixed from three stable stock solutions. These are combined just before coating the emulsion onto the paper, which can be sized or not, depending on the nature of the paper stock. Contrast in the final print is controlled by the ratio of these three stock solutions. Because of the cost of the platinum salts, only a small amount of emulsion is made up at any one time. Therefore, it is recommended that the three solutions are stored in medicine dropper bottles and the emulsion measured out as a number of drops. These solutions should store reasonably well in the medicine dropper bottles, as long as the bottles are a dark brown colour and not exposed to daylight.

This emulsion is relatively insensitive to light so it can be mixed and

coated in low, artificial light conditions. Before coating, heat the paper to be coated for several seconds in front of an electric radiant heater or hotplate to drive out any moisture. As the emulsion is so expensive, it must be coated with great care. Normal brushing or latex rolling techniques would be too wasteful. A brush can be used if it has very few hairs or bristles, so that there is no undue absorption of the emulsion into the brush. A very small buckle brush works well, or better still, the emulsion can be sprayed on using an aerograph or model maker's spraygun. In this way, almost all of the emulsion reaches the paper surface.

After the emulsion has been mixed, coated and dried in a stream of warm air, it must be finally heated for a few seconds by a radiant electric hotplate or heater. Do not overheat. The emulsion is ready when the paper crackles. Expose immediately and make sure, before printing, that the contact printing frame is perfectly dry. Remember, wood, cloth and latex foam all take up moisture. Even the glass, if too cold, will cause aerial moisture to condense onto its surface. Water is the great enemy of the platinotype.

The platinotype is, in part, a printing-out process, with subsequent image development in a potassium oxalate developer, which is either worked hot or cold. The cold development gives more neutral blue-black tones, whereas hot development turns the shadow to a warm brown-black tone. This chemical may be worked to completion, even though it looks very muddy and soup-like in the final stages of its life. Exposure estimation in this process is therefore difficult. A simple guide to the correct exposure is that the shadows just show, but for a more accurate estimation an actinometer must be used as in the carbon processes described in Chapter 3.

The developed print contains both platinum and iron salts. The iron is removed in a clearing or fixing bath made up of three dishes each containing a 1.5% solution of hydrochloric acid (concentrated). The print is moved through the three baths at five minute intervals, then washed thoroughly for 20–30 minutes in fresh running water, and finally dried in a stream of hot air.

Some modification of the process is achieved by adding gold, mercury or lead compounds to the emulsion before coating and processing. Lead gives a less brown tone and increases contrast slightly. Gold increases the density of the image, changing its colour towards purple. When mercury is added at the same time as the gold, there is a reinforcement of warmth and density in the final image.

Kallitype This process is very similar in chemistry to the Van Dyke or sepia paper method, in that being a silver-iron process, the silver salt is reduced at the same time as the ferric salt to a metallic compound, by exposure to light. It has a surface quality, however, resembling that of the platinotype and, as such, offers a much more economic

alternative. Unfortunately, it also suffers from the same image insta- bility as all the other silver processes. The kallitype process works in exactly the same way as the platinotype. The emulsion is a simpler mixture of ferric oxalate, oxalic acid and silver nitrate, which is spread onto the paper by floating or the use of the brush.

When the coated paper has been dried and warmed in the same manner as in the platinotype process, it is immediately exposed. A fully printed out image is not produced. Exposure is complete when the shadows are fully visible. The image should look pale brown, against a yellow background. If this method proves too inaccurate, employ the standard actinometer technique (see page 18).

After exposure, the print is ready for development in a mixture of potassium tartrate, borax and potassium bichromate. The development may be undertaken in weak artificial illumination. The image should appear in a few seconds. Leave the print in the developer for a full five minutes to ensure adequate development. The print is rinsed and then fixed in a 2% solution of sodium thiosulphate, passed through a hypo elimination bath, thoroughly washed and dried.

If desired, the finished kallitype print may be toned in any of the toners suitable for the silver salted print out paper.

URANIUM PRINTING

History The first uranium printing processes were worked out by J C Burnett in 1857/8 and also Niépce de Saint Victor who took out an English patent in 1858. Both of these gentlemen have other claims to fame: J C Burnett helped to develop both the carbon process and platinotype, Niépce de Saint Victor suggested the use of albumen as a binder for the coating of a silver emulsion onto glass and paper.

Uranium formed the basis of a number of mixed metallic processes. Wothly's process of 1864 employed a mixture of silver and uranium mixed in a collodion emulsion, similar in working to Frederick Scott-Archer's wet collodion emulsion. Dr J Bartlett's (1906) process was extremely sensitive to light, so much so that an exposure of five seconds for sunlight was all that was required, but this process was, in effect, very similar to conventional silver developing-out paper and offered no serious advantages.

Uranium nitrate is sensitive to light in its own right and does not need the help of other light sensitive metallic compounds.

Basic processes The uranium printing process although suffering from all the weaknesses of the silver processes, is simpler and does provide an astonishing range of fully saturated image colour. It gives prints which show pleasing terracotta or copper colour by simply coating and printing out the image by conventional sunprinting procedures.

After exposure, all that is needed is a wash in two or three changes of water and the processing is complete.

Further colour changes are produced by placing the processed print in a 5% potassium ferricyanide solution which has been acidified with nitric acid. This turns the print bright red. This red print can be further changed and made to turn greenish blue by treating it with a 4% solution of ferrous sulphate acidified with sulphuric acid, or if a 2% cobalt nitrate solution is used a bright green colour is produced. These are not the only changes possible to wring out of the humble uranium print, for, if one of these colours is painted with a 5% solution of chloride of gold, violet tones are produced. On the other hand, a silver nitrate solution produces a greyish black similar to a platinotype. Unfortunately, uranium prints are not very permanent, but they do give unique effects. If more permanent results are required, then the print can be simply copied directly onto Cibachrome colour paper, or normal transparency material and then printed onto Cibachrome material.

Conclusion It is obvious that a great deal of creative potential lies dormant in this process. To be able to produce almost a spectrum of colours from a single print by the application of weak toning baths allows considerable scope for skilful autographic application and/or imaginative stencil printing technique.

It is very important to realize that once the ideas of the standard photographic print processes are discarded in favour of the more liberal sunprinting approach, anything goes! Prints are no longer identical. Each print has its own individual character. The final result is a process of personal choice rather than slavish adherence to arbitrary values. The sunprint, whether it be in metal, pigment or dye, or for that matter, a combination of all three, is unique. No two prints can be the same because of the nature of the manufacturing processes

DAGUERREOTYPE

Originally it was not intended to include this early historic process as practical experimentation has shown that the initial preparation of the base material i.e. the silver coating of a copper plate, is a very difficult task, and also quite expensive if things go wrong. However, a recent article by Hans Zaepernicks in *The British Journal of Photography* (26th January 1979) provides a very elegant and economic solution to this problem.

History The daguerreotype was invented by Louis Daguerre in 1839. This extremely beautiful process was aptly nicknamed 'A Mirror with a Memory'. The daguerreotype consisted of a metal plate, usually

copper, which was coated by electroplating, with a thin layer of silver. This silver coating was made light sensitive by fuming with iodine vapour, followed by bromine vapour. The resultant daguerreotype plate was then exposed in the camera. The exposed plate was developed by fuming with mercury vapour, progress being judged visually. When the image had reached its full strength it was then toned and fixed either separately or in a combined bath.

Basic process Hans Zaepernicks' method suggests the use of an ordinary silvered mirror as the basis of the process and a positive continuous tone transparency printed onto the photosensitized mirror surface by the familiar sunprinting technique. The use of the silvered mirror avoids all the problems inherent in electroplating copper with silver and like many good ideas it is simple and efficient in concept.

Starting with an ordinary commercial mirror, it is necessary to remove the varnish from the silver side, which is easily done by immersing the glass, silvered side up, in a strong solution of denatured alcohol. After twenty to thirty minutes, the red varnish may be gently rubbed off with a swab of cotton wool, wetted with alcohol, and the final cleansing effected by repeated rinsing with alcohol. The silver film is thus laid bare. As it is easily scratched, carefully rinse it in distilled water and dry it in a current of warm air.

Before use, the plate must be polished. For this use a pad made of the finest chamois leather, about as big as a fist and tightly filled with cotton wool. Then polish the plate with jewellers' rouge. Sensitizing is effected by iodine vapour. To this end, construct a box in which a porcelain dish is placed with a few grammes of iodine in it. A 9 × 12 cm plate would need a box 18 cm (7 in) deep by 10 cm (4 in) broad, fix the plate in the top of the box and place a lid on the box. It is important that this sensitizing is carried out in a well-ventilated room. Weak artificial light or yellow safelighting must be used in the processing and printing stages, as once the plate is iodized it becomes fairly sensitive to daylight.

The correct moment to stop iodizing is when the silvered mirror assumes a beautiful golden yellow with a slightly rosy tinge. It is advisable to print the plate directly after iodizing, as, if left too long, it develops unevenly. The plate, transparency and contact printing frame must be absolutely free of dust and cleanliness is essential. The printing is done by ordinary daylight, near a window. Normally, from two to four seconds will be required for exposure and the plate should be developed at once.

The exposed plate is developed in a box of similar construction to the iodizing box but with a metal bottom made of iron or mild steel. Place the mercury in a small porcelain dish. Then fix a thermometer through one side of the box at an angle, so that the bulb of the thermometer dips into the mercury and the temperature can be read

93

with greater convenience from the outside of the developing box.

After the plate has been fastened to the lid, rapidly heat the mercury up to 60–65C (145–155F), with a gas or spirit lamp placed under the iron bottom. When this temperature is reached, the flame should be withdrawn at once. The development may be watched under yellow safelights or weak tungsten illumination. Development is finished, at the longest, in two minutes.

The picture should be fixed at once by pouring some hypo solution over it, and then rinsed in distilled water and allowed to dry. The picture is intensified and made warmer in tone by using a gold toning bath. Although the picture gains somewhat by gilding, it is frequently spoilt by this process, as the silver film may peel in spots. Gilding is not absolutely necessary. This method, unlike the other processes in this book, has not been validated by the author, but should prove sound in practice.

CAUTION!! *When this article was originally written, the poisonous nature of mercury was not fully realized. The fumes from the mercury dish should on no account be inhaled, and great care must be taken when handling this dangerous chemical.*

6. Autographic Applications

Introduction This section introduces the creative sunprinter to the numerous ways in which hand work can modify the printed image—a purely 'nuts and bolts' section concerned mainly with the 'how' rather than the 'why'. However, some comment must be made as to the validity of autographic or hand work on photographs. The hand colouring of daguerreotypes in the early days of photography was considered a 'rank perversion of photography' by the photographic purists, 'a dreadful imitation of painting' by artists, fearful for their livelihood. The battle is still raging. Adding colour to monochrome photographs has remained the most disputed area. Until recently, the colour print produced by conventional processes left a great deal to be desired, being of generally poor quality compared to, for instance, colour transparency work. High quality prints were available if produced by highly complex and expensive print processes, such as the dye transfer process and earlier the trichrome carbro process.

Hand colouring on the other hand is simple, cheap and, in the hands of an expert, a very effective process, allowing great personal freedom of expression. With the development of cheap high quality colour print processes, the balance could be redressed and colouring take on a new phase, instead of being purely imitative of conventional colour photography. It may offer an opportunity for the creative worker to experiment with the more expressionistic side of colour work. Subjective interpretation rather than factual copying of colour relationships should be the aim. Once the creative sunprinter breaks the bonds of objective criteria, a new exciting world of fantasy opens up, which can give great joy and personal satisfaction.

Creative approach Creativity must be the key to successful autographic application. A dictionary definition of creativity which is very appropriate is 'To create: to bring into being by the force of imagination.'

Be creative. Try new ideas or original variations on old ideas. Be adventurous. Do not be contained by the restrictions of outmoded convention. Try to balance an aggressive approach with a desire for sensitive unity. What is important is to try and try again. In the process of experimentation a great number of mistakes are bound to be made. Do not worry about this. Select the effective work from the rest, then build on that. After a lot of sweat and tears an individual style and purpose to the work will emerge phoenix-like from the ashes. This is both the hell and the heaven of the creative approach.

Have fun with colour. Hand colour your sunprints. Be content at first to use simple mass tinting, covering general areas. Contrast, then harmonize colour and see what happens. From this information learn and build. Use tone, either grey dye or graphite. Merge and smudge. Use your fingers, cotton wool pads or a spray gun to produce the tone. Texture is also exploited by the use of pressure adhesive textures, offset texture printed from cloth, wood, grain glass, sand paper. Apply these to the surface of the print by first rolling up with lino or litho ink on the above textures and then pressing them into contact with the print. It is quite possible that some damage may occur to the original print. In this case observe what has happened, then, if necessary, reprint. Become free and fluid in your work. Have fun as well as achieving intellectual satisfaction. Remember the art of a young child has a freedom and purity of expression that some major mature artists have spent a lifetime trying to recapture. A child makes images in a purely spontaneous manner in response to an inner need or desire. The creative sunprinter should attempt to achieve a similar uninhibited state of mind.

COLOURING THE IMAGE

Introduction Colour can be applied to the surface of a sunprint by the use of a number of differing colour mediums, each having its own unique characteristics. In addition, the nature of the surface of the sunprint, its absorbency and texture, also seriously affect the final result. The more absorbent the paper surface, the deeper the colour density and saturation. The ideal surface is similar to a matt photographic print. This surface will take almost any colour mediums to the right degree of saturation. It may, therefore, be necessary to add a colour accepting layer to a non-absorbent base, or conversely, reduce the absorbency of a base which is too absorbent by filling in with a non-absorbent varnish or size.

The approach to colouring is governed by the original intention. The sunprint can either be retouched to correct for error in, say, printing or to give a slightly greater range to the printed colours already present in the picture. For instance, a landscape which consists of a cornfield

A welsh slate wall photographed in early spring on orwochrome slide material. From this slide two colour separation negatives were made which were then printed via the oil transfer process. Local colour was controlled by the use of autographic techniques using oil colour pigments.

This print originated from a single 6 × 6 cm Tri-X negative. A very small portion of the negative was enlarged to give three separate high contrast negatives. These were then printed, via the gum-bichromate process, in yellow ochre, Van Dyke brown and black pigment.

A moody winter interpretation printed as a duotone in cerulean blue. The print consists of a gum emulsion on a grey silver halide print, obtained from a single high contrast texture tone negative. The original 35 mm Tri-X negative was overexposed and overdeveloped to increase the graininess and apparent contrast in the scene.

A transparency provided the starting point for this picture, taken at dusk when the light was very weak and a slow shutter speed was necessary, causing a softening of shape and colour. Three low contrast colour separations were made using autographic methods (see Chapter 4) and these were printed using the oil and gum methods.

An image which started as a P84 photographic document print, heavily retouched with pencil which then underwent considerable change through numerous monochromatic separations to be finally printed in oil colour. The original picture was on 6 × 6 Tri-X film.

The original 4 × 5 in black-and-white negative was the starting point for a series of modifications and derivations by experimental print making procedures. The final purple and yellow image was only achieved after hours of trial and error, starting out originally as red and blue. The simplicity of the gum-bichromate process made this degree of experimentation possible.

and sky can be multiple printed yellow for the corn and blue for the sky, but if a few small spots of scarlet are carefully touched in to give the impression of poppies, the scale or range of the print is greatly increased.

Another approach is to sunprint with autographic colouring in mind as an end of the process. In this case the sunprint should be light and soft in tone and contrast. For portraiture a weak sepia tone is best.

Remember that the sunprint itself should dictate the way the colour is applied. Always be true to the original visual concept.

Watercolour The handling of watercolours presents more difficulties to the beginner than any of the other colouring mediums. This can, of course, also be said of watercolour painting. Delicate handling of this medium is essential if mastery is to be obtained. The process is very watery and relies on successive washes of dilute pigment, which are built up on the image to colour it—an additive process, one colour laid upon the next.

It is important to have good quality materials. In the first place a nest of china pans or saucers are needed to mix the colour and a set of brushes—red sable are the best but they are very expensive. The sizes that are needed are Nos. 2, 4, 5, 6 and 10, Nos. 4 and 6 being the most popular for general use. A soft sponge and several sheets of fluffless blotting paper and a large jar to hold the water are also needed.

The actual watercolour pigment itself should be of artists' quality supplied by a reputable maker. A great range of colours is not required. The range can be extended or contracted at the personal discretion of the colourist. Here is a selection of essential pigments containing cadmium yellow, indian yellow, yellow ochre, raw sienna, burnt umber, cobalt blue, ultramarine blue, prussian blue, crimson alzarin, light red, raw umber and viridian green.

The print is prepared for colouring by giving it a thorough soak in tepid water until limp. Then remove it and squeegee it onto a sheet of glass or Formica-faced chipboard. Raise the glass to an angle of approximately 30°. The print is allowed to dry until it reaches a damp/dry condition when it is ready for colouring.

Use plenty of water when preparing a tint. Artists' watercolour is strong and consequently economical to use. Very little pigment should be used.

To lay a wash, use as large a brush as possible for the colour area selected. When the brush is fully charged with colour apply it confidently across the top of the area to be coloured. The angle of the board will cause the colour to collect along the bottom edge, where it will be gathered up on the next sweep of the brush. In this manner the wash is evenly laid over the print.

The large separate areas of colour in the print are laid down first in a series of dilute washes. If a landscape is the subject, the sky is the

97

first area to be dealt with. A large brush is needed to lay an even wash of blue. The first wash must be very watery and must be laid right down to the skyline or the edges of any clouds present. Now steadily build up the colour of the sky by successive washes moving closer and closer to the top of the picture. If the clouds in the picture have any shadow, this must be painted in as a slight grey/purple tone. The treatment of the sky must be such as to preserve an airiness, a sense of light and space. It may be better to make the washes too light until the rest of the print has received colour.

The foliage of the landscape is worked over in the same way as the sky, but with green instead of blue. The first wash may be diluted with some of the sky blue again. The wash must be laid right up to the edge of the skyline. As the wash progresses towards the middle distance more green is added. When the foreground is reached, the colour is changed to give a colder green to the foliage, to preserve a sense of aerial perspective. Now fill in detail colour using a small brush. Careful stippling with these detail brushes can give a velvety quality to the image. Remember, the value of watercolour lies in the soft, delicate nature of the medium. Use this quality with sensitivity.

Dye tinting This is very similar to watercolour, but is essentially a grosser process, not capable of the same delicate quality, being bolder and more virile in character.

To use dye effectively the print must accept dye easily. A gelatin surface is ideal in this respect. If the sunprint has an unsuitable surface, a layer of insoluble gelatin must be laid over the printed image so that the dye will take. (For methods of coating gelatin see page 22.)

Large areas of colour are built up in a similar manner to watercolour. Tufts or pads of cotton wall are used instead of brushes. Dye is more liable to show a streaky appearance when dry so care must be taken to build up the area with successive washes of dilute dye, blotted between each application. If the print is first soaked in a water bath containing a strong wetting agent, streaking is minimized, and/or the wetting agent can be added to either the tints or the water used to dilute them.

Overtinting can be simply remedied by a process of soaking in clean water or careful use of a soft sponge and a final rinse under a running tap followed by immediate blotting of the surplus water on the surface of the print.

Dye has a strange hallucinatory quality. It lies beneath the surface of the print, mysterious and, at the same time, compelling and having the effect of almost crying out for attention—ideal for dramatic images.

Pastels The pastel offers a complete contrast to both watercolour and dye as an image colourant. Pastels come either in the soft greasy variety or as a hard chalky medium. It is this latter type of pastel which is used.

It is important that the print has a comparatively coarse, rough texture to its surface with plenty of 'tooth', or the effect of the pastel will slight. With this medium one must endeavour to convey a broad impression of colour, rather than working in fine details. The best effects are gained when the pastels are used sparingly.

It is best to work with stumps made of paper or kid leather. These stumps are known as tortillion and resemble a thick, blunt ended pencil. Rub the pastel on the point of the stump and then rub this on part of the print to be coloured. Corrections are made by using an india rubber.

When the work is completed, a fixative spray is used to set the particles of pastel firmly onto the paper. This treatment is essential as pastel colouring will not stand up to excessive handling.

This is a soft impressionistic method of colouring. Delicate and slight subject matter is best. It is ideal when used in conjunction with the gum-bichro image, the two types of image quality blend and complement each other, one merging into the other.

Oilcolouring This is considered to be the aristocrat of the photocolouring systems, partly because of the richness inherent in oilcolour, but more so on account of the ease with which the colours can be applied and removed almost at will. The procedure is the reverse of watercolour in that the colour is put down on the print more strongly than is necessary, then slowly removed until the correct density of colour is achieved. In this way the process is said to be subtractive in character, the reverse of the additive nature of watercolour. A more precise control of the colour is possible due to this flexibility of application.

The print is best prepared by dampening, then attaching to a drawing board by standard brown gum tape. The print is then thoroughly dried, when it should be in the proper condition to be coloured with oilcolour. It is important that only transparent oilcolours are used if the true beauty of the process is to be fully realized. The print is given a complete covering of medium made up of one part copal varnish to one part boiled linseed oil to four parts of pure spirits of turpentine, fairly heavily applied. This is then partially removed by careful polishing with a pad of clean cloth. A number of artist suppliers, such as Winsor and Newton, market oil photocolouring outfits.

The main areas of colour are put down onto the print with a pad of cotton wool soaked in the appropriate colour which has been diluted with transparent medium, as oilcolour is generally very intense and needs dilution in this manner. Cover the whole area even if some of the small details within the colour area may need to be in a different colour. These areas will be dealt with later. The main colour is now removed by polishing the area with a pad of clean cotton wool screwed up into a tight hard pad. Continue polishing until the right level of colour is achieved, then move onto the next large area of a different colour and repeat the process. When all the major areas of colour have

100

been dealt with, move onto the highlight tone of each area and lighten them by selective polishing. Here, very small pads (e.g. baby cotton buds) are extremely useful. The shadow areas will now need attention. Shadow colour can be either warmer or colder than the general colour depending on the subject matter. Alter the colour to suit personal taste. At this stage the small areas of alternative colour within large areas of general colour are dealt with, for instance, the colour of the eyes in a portrait. First load a brush with medium, then apply the brush to the area where it is required to clear the prevailing colour. Now stipple the new colour into that area. Sometimes a careful smudging along the edge on one colour into the next will help to give a smooth blending of one colour into another, providing satisfying colour harmony.

When colouring, have an overall plan. It is useful to draw a colour outline sketch of the colour areas in the print before starting to colour, but do not forget instinct. If the result looks right, it is right, however bizarre the colours. Also, do not rely on memory, which is notoriously inaccurate. If you have an *aide-mémoire*, such as a colour slide or picture postcard, use it. This does not mean that a slavish copy of such an *aide* should be made, but the *aide* is bound to provide half forgotten information which may help to give additional visual stimulation.

DRAWN IMAGES

Painters and graphic artists have used the optical image as a basis for their work for centuries. Long before the invention of photography, Vermeer, Canaletto, even Leonardo da Vinci, used the *camera obscura* as an aid to drawing and it is a known fact that many modern artists have relied heavily on the photographic image, not only as an aid to drawing, but also as a source of visual inspiration. Francis Bacon, Larry Rivers, Paul Nash, David Hockney, Andy Warhol, Monet, Delacroix, Robert Raushenberg, have all openly acknowledged their debt to the photographic image.

There is no reason why the photographer should not reciprocate and use drawings as part of photographic image making, if not as a source of inspiration, certainly as a useful extension of personal vision. The problem with drawing is that to achieve a reasonable facility with the pencil or pen one has to undergo a long period of intense training. It tends to be a knack which few can master easily. This is all very well for the favoured few, but does not help the majority who would like to use the drawn image. Many photographers are in fact frustrated draughtsmen, and took up photography because they could not draw well enough. This basic feeling of inferiority quite often underlies the fanatical purist philosophy of photography.

Bleach-out process This process allows strong line drawings to be made with the minimum of drawing skill. All that is needed is a reasonably steady hand and an eye for detail. The photographic procedure is extremely simple. A light, soft print is made full of detail in both highlight and shadow areas. Overexposure and underdevelopment provides the right kind of print for this process. A matt print is easiest to work on, and should have been fixed in an acid hardening fixer and given a thorough wash.

The print is prepared for ink in the same manner as a print which is going to be coloured by the oilcolouring process, soaked, then gum taped to a drawing board, where it completely dries before work on it can commence.

Artists' drawing pens of assorted sizes are needed, or the rapidograph/isograph type of graphic designers' pen with nibs of differing sizes which are very accurate and precise to work with. The artists' drawing pens have more character. Good quality completely waterproof ink is required which will withstand immersion in water.

Now comes the most fascinating part of the process—making the actual drawing. With an extra guideprint, study the masses of shadow which build up the light and shade of the picture. Draw over these shadow shapes with thick lines. Block in the deepest shadow areas solidly, then draw more delicately over the lighter portions. When the main forms and shapes of the picture are sufficiently defined, work in

the finer detail with a thinner line, using a finer nibbed pen. Continue until the whole print has been drawn over.

The quality of the line is the distinguishing mark of a good drawing. 'Quality' means the variation in line thickness—the general firmness and clearness of the line. A certain degree of speed is required to get a good flowing line. One drawn too slowly is apt to be stiff and lacking in the desired quality.

Selection of image content must be made if the finished result is not to appear too crowded. This power of selection is one of the main advantages of the process. Unnecessary detail should be avoided and the major features strongly enhanced.

When the ink is thoroughly dry and not before, the print will be ready for bleaching. Use standard iodine bleach for total silver removal from the print without leaving a residual stain image. If the original print is very light and soft with no heavy shadows, Farmers' reducer will work satisfactorily. Be careful not to touch the ink lines, as at this stage these are soft and easily smeared. Once bleached, the print should be carefully dried in a stream of hot air.

After the bleached image has dried, some additional work to it may be required. Compare the drawing with the guide print. The deeply shaded portions will probably appear too light, because too thin a line or too few lines have been used. These lines must be thickened or added to until the tones look about right. Where the lines are too thick, corrections can be made by either using liquid corrector as employed by typists, or process white watercolour pigment. A sharp scalpel may also be used, sometimes to open up shadow detail by incising thin white lines in solid inked areas.

The resultant bleach-out line drawing can now be contacted onto photographic paper or film to become a line negative suitable for further creative sunprinting.

Tone drawing Sometimes a line drawing is far too hard or harsh for the desired effect and a softer more tonal result is looked for.

This type of result is obtained quite simply by placing a negative in an enlarger and projecting the image down onto a sheet of drawing paper. The negative image is now carefully shaded until all the tones are made equal and the image is practically eliminated. Start with the brightest and lightest shadow tone and shade until it matches the darkest highlight tone, then take the next lightest shadow tone and shade in that. Carry on until the picture is completely darkened all over. Switch off the enlarger and turn on the darkroom light. There should now be a positive picture in graphite displaying all the tonal quality of a pencil drawing. To work and draw under an enlarger in the dark is no easy matter. A simpler method is to produce a negative print on thin base paper made translucent by one of the methods described in Chapter 2.

This paper negative is placed on a light box and carefully masked

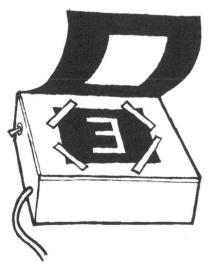

with black paper or opaque paper to reduce light box glare which can strain the eyes. A sheet of tracing paper or Kodatrace is taped to the negative print and the same method of shading as previously described for use with the enlarger is undertaken, resulting in a positive on tracing paper or Kodatrace. This graphite positive can be contact printed onto photographic paper or film as described in the bleach-out process or it can now be taped down onto the light box in place of the paper negative, and the shading procedure repeated on tracing paper or Kodatrace. A very graphic negative is produced—highly suitable for creative exploration and further sunprinting.

These graphite negatives can be produced using any strong positive image, preferably transmitted via a light box. But it is possible to use reflection positives—images culled from books, newspapers, magazines etc.—if a strong light such as a draughtsman's lamp is shone on the work. The creative possibilities that this technique opens up are almost unlimited. Only the scope of imagination of the creative sunprinter will set the limits.

7. Sun Pictures in Dye

A pinch of explosive powder can often cause violent physical disturbance and change, and in a similar manner a small quantity of dyestuff in powder form instantly produces dyes which radiate pure transparent colour inherently violent in visual effect and always highly saturated. Colouration of this nature can only be diminished or weakened by successive dilution. A delicate pastel colour sometimes represents a million to one dilution from the original solid dyestuff.

These unique qualities of strength, colour and transparency have, in a number of ways, made the dye an ideal colourant in photographic systems, even though it is difficult to find or make suitable dyes for perfect trichromatic colour reproduction, as most dyestuffs fade when subjected to strong sunlight. In fact, a process of dye image making relies on the principle that certain dyes are bleached by light.

Most modern photographic colour processes are based on making use of the production of the dye during the processing cycle. An exception to this is the Cibachrome process, where the dyes are already present in the emulsion and are destroyed by the action of bleaching a silver image. The former processes of dye manufacture during processing have led to that modern miracle of technology, the colour integral tripack emulsion, making possible the almost universal use of colour photography as we understand it today.

This integral tripack method of manufacture and usage is extremely advantageous in that it provides a simplification of the complex problems of emulsion mechanics, and allows trouble-free colour photography. On the face of it, this is very laudable, but this apparent freedom from technical complexity has its price, and what is gained on the technological roundabouts, is lost on the creative swings. Creative control of one colour area in relation to the next, is almost impossible when using most of the modern colour materials. Because these materials, particularly dyes, are very attractive to look at this lack of control is not often noticed and, therefore, seldom missed. But try to

106

imagine monochromatic photography without local density control, or with little or no contrast control, and the nature of the loss is more easily understood.

The masters of modern colour photography such as Ernst Haas, Harold Mante, Sarah Moon, have to a great extent searched for and found creative colour relationships present in the subject itself, exerting little or no control over the process. Sometimes, however, the character of the process is used. The dull, desaturated colour of Sarah Moon's moody portraits or the use of extremely long focal length lenses by Ernst Haas, are examples of elegant solutions to this problem. However, the lack of colour control still remains despite the fact that ways have been found of avoiding this basic problem.

Some workers do show the way. For example, Peter Turner's evocative and at the same time simplistic imagery and the elegant work of

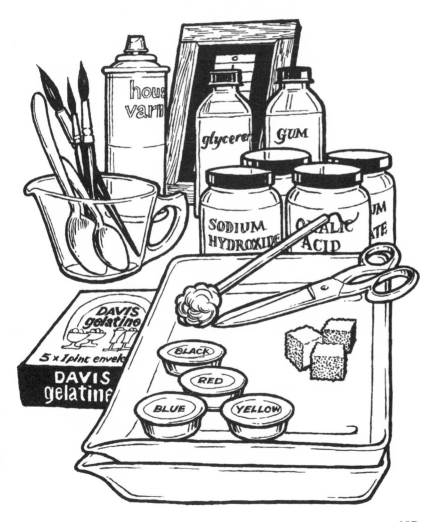

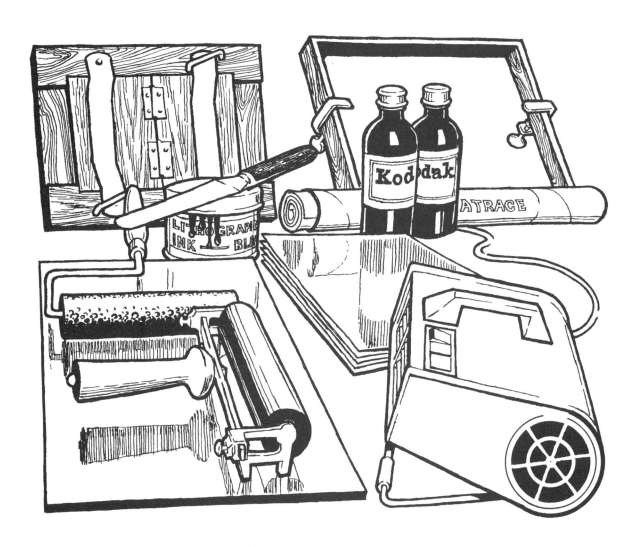

Hiro which shows oriental delicacy and sophistication. Also the work of the sunprinters, Betty Hann and Scott Hyde, although mainly involved with the pigment processes, points the way to colour control in the dye processes as an answer to this problem.

DIAZO

Introduction Most people are only too aware of the disastrous effect direct sunlight can have on curtains, carpets, furnishing fabrics and clothing. The highly actinic, ultra-violet radiation, plentiful in sunlight, readily bleaches the colours. Even household paint will, after sufficient exposure, finally succumb to this destructive radiation, and fade. Although the bleaching of colour by sunlight is a disadvantage in most

108

situations this photochemical reaction can be used to advantage in the course of creative sunprinting.

Certain dyes are known as *diazo* which is a simple abbreviation of diazonium, a term applied to a particular type of chemical.

History Some ten years after discovering diazonium salts, Peter Griess produced the first azo dye in 1859 at the Royal College of Science. However, it was not until 1881 that two French scientists, Bertholot and Vieille, recorded its light-sensitive properties. Within a few years this material was used by Freer in 1889 and then by Green, Cross and Bevan, who patented in 1890 the first workable diazo method, known as the primuline process.

It was a German monk who first appreciated the real potential of diazo. Seeking a means of duplicating to avoid time wasting transcription, brother Gusta Koegel gained the interest of the Kalle chemical company of Germany. With their assistance, the first commercial process was patented in 1922. Materials of this type were given the trade name *Ozalid*, a simple reversal of the word 'diazo' with an added 'l' to simplify pronunciation.

This ozalid process has been mainly used for low cost, high speed drawing office and technical reproduction purposes. Most engineering and architectural establishments employ this highly cost effective process.

Basic process The chemistry of the process is fairly complex. The diazo compounds have the property of combining or coupling with other organic substances in the presence of an alkali to form even more complex compounds, many of which are highly coloured. It is precisely this further coupling or developing of the original diazo compound that produces the brilliant dye colour characteristic of this process. When the sensitized diazo compound is exposed to sunlight this power to 'couple' with other dye manufacturing compounds is lost, and upon this fact the various diazo dye printing processes are based.

Paper coated with diazo compound is exposed under a positive film and then swabbed with an alkaline solution of the coupling agent. The coupling agent or developer will only bring out the dye colour strongly in areas receiving little or no exposure to sunlight, therefore, the shadow areas in the print, having received little or no light from the positive will appear deeply coloured. Conversely, the compounds in the highlight area which have received the most exposure will hardly react to the 'coupling' agent, being more or less completely destroyed by the photochemical reaction of the compound to sunlight. Therefore, this process can be said to be positive/positive in action.

Primuline/Diazo Although ready-prepared commercial diazo products are available, which are reasonable in price and very simple to work,

the sunprinter can still make his own materials by updating the ancient primuline process. This method has been employed quite extensively in the textile and fabric design industry, but seldom worked as a means of colour photography, despite the fact that a good range of colours is possible. When using it, yellow, orange, red, blue, brown and purple dyes are easily produced, these being of high saturation.

Theoretically, multiple coating and exposure is possible when working this process, but, in practice, only single image manufacture is feasible, due to the build up of 'colourless' compounds in the highlight area of the print. These compounds are not in fact completely colourless, and with successive printing would seriously degrade the whites and highlight values of the print. Another problem lies in the nature of the diazo image itself. As previously stated, diazo dyes are extremely saturated due to high dye opacity. When dense images of this type are brought together, the resulting print quickly becomes too dark and heavy in tone, if more than three images are printed. However, a flat colour assemblage approach to this problem is easily employed, which avoids some of the restraints on the use of the process.

A positive will need to be printed on a piece of fixed out and thoroughly washed, resin coated photographic paper, a paper which is ideal for use as the base material. The resin coated paper is first presensitized by soaking in a hot 1% solution of primuline in distilled water for five to ten minutes. Then drain and rinse it in water for a few seconds and hang up to dry in a current of warm air. The resin coated material can be left for future printing or sensitized immediately and printed. To sensitize it to light, immerse it in a solution of sodium nitrate and oxalic acid. It should then be drained, given a brief rinse, and all the surplus moisture removed by blotting between pads of blotting paper. This work must be done under red or yellow safe lighting, or in very weak artificial illumination, as the paper is now light sensitive. It need not be absolutely dry before exposing, and must be exposed at once.

Standard sunprinting technique is employed in the printing. Exposure of a positive transparency to the diazo-sensitized resin coated paper should take between thirty seconds to three minutes in direct sunlight. To gauge exposure, expose some small off-cuts of resin coated paper beside the frame and continue exposure until they no longer give a colour when tested with the 'coupling' developer that is to be used. The standard test strip procedure is also applicable. After exposure, develop the print by swabbing it with a large buckle brush containing the appropriate colour developer. Development is almost immediate, allowing little or no development control.

A multicoloured print is produced by the use of differing colour developers, carefully applied to the print by the use of a camel's hair brush. The beauty of this technique is that the tonal values are kept in correct relationship automatically, as these are governed by the tonal

range produced by the positive transparency exposure. A second sensitization is now given to the print and a positive is exposed which contains only the shadow tones. A purple or brown developer is employed to complete the picture. Some loss of highlight quality is bound to occur, but can be partially remedied by soaking the print in a weak bath of sodium hypochlorate which 'cleans out' the highlights.

3M Color Key Trichromatic results are easily achieved by the use of this system of colour proofing. Color key is a commercial method of proofing four colour halftone negative or positive separations, before committal to expensive photomechanical printmaking. It is a fast, mechanically smooth process, which is entirely dependable. It offers standard subtractive primary colours such as yellow, magenta and cyan, and the complementary secondaries blue, green and red, plus a number of other colours, which are either positive or negative working. The material is in the form of very thin transparent sheets, which are laid one over the other, and are then bound together with tape onto a piece of white paper, which forms the base of the colour print. The colour image is, in fact, a sandwich of clear acetate foils containing appropriate diazo colour separations.

The 3M Color Key material is first exposed by conventional sunprinting technique and developed with a proprietary developer. Development consists of swabbing the exposed plastic sheet with developer applied with a large buckle brush, in a similar manner to the primuline process. The object is to remove the dye substances affected by light and development. The film or foil is rinsed to remove the excess developer and solid waste, and then dried between pads of blotting paper. Once it is dry it may be staked in register with the colour proofs made from the rest of the halftone colour separations.

Texture tone or colotype separations are also highly suitable as an alternative to the halftone, and flat colour assemblage separation technique is perfectly acceptable when working this flexible system of coloured diazo printmaking. If the foil sandwich is found to be unacceptable for print exhibition, then a Cibachrome print is easily made from the diazo sandwich. This procedure has the advantage of producing a final print which is comparatively stable dimensionally.

DYE TRANSFER

Introduction Most dyestuffs will travel by a process of imbibing from one layer of gelatin to another, especially if the receiving gelatin layer is properly conditioned. This facility allows for a dye transfer system of sunprinting to be worked.

The Kodak dye transfer process provides a basis for this sunprinting system. It allows control of contrast and colour and there is balance in

every step of the process. It offers unequalled photographic quality if used conventionally, and tremendous flexibility when a more creative, experimental approach is taken.

To convert the Kodak system so that conventional sunprinting technique is suitable, the matrix material must be discarded, being far too light-sensitive and expensive for general use. In its place, a bichromated, gelatin coated piece of Kodatrace is employed. From this material a gelatin relief matrix is made by exposing a continuous tone negative through the *base* of the Kodatrace by the visual sunprinting technique. After exposure, the matrix is placed in hot water and the unexposed gelatin dissolved away to leave a relief image in hardened or tanned gelatin, the variable thicknesses of which represent the tonal gradation in the final dye transfer print.

Kodak dye transfer paper can be used, or any other gelatin coated paper, as long as it has a glossy surface and a thick layer of gelatin to take up the dye. Homemade gelatin paper is very suitable as mordants can be included in the manufacture and a vast range of base materials become possible.

Kodak dye baths and buffer solutions allow for precise control of the process, whatever the printmaking system employed, whether it be the trichromatic system or the more creative flat colour assemblage method as outlined in Chapter 4.

There is a considerable advantage in modifying an existing dye printing system as all the control procedures are already in existence. This saves the sunprinter lengthy research and experimentation.

Basic processes Kodatrace is coated with a layer of soft gelatin made light-sensitive by the addition of ammonium bichromate. The material is coated on the matt side. Any of the coating procedures previously described (pages 22–23) should prove suitable.

When the Kodatrace, plus emulsion, is perfectly dry, exposure is by standard sunprinting technique. The negative must be exposed through the Kodatrace base and not face to face as the image will float off the base material on development. The exposure is judged by actinometer, in exactly the same manner as for a carbon print. Only a faint image should be visible and it is, therefore, impossible to judge exposure accurately by visual assessment alone. If the lighting conditions are stable with little or no fluctuation of light level, then a test strip that is printed directly following exposure and developed, should provide an accurate alternative to the actinometer for the judgment of correct exposure. Development is simply achieved by soaking the exposed matrix in hot water 38–50C (100–120F) which dissolves the unexposed gelatin, leaving just the relief matrix in hardened gelatin. Two to three minutes should suffice for complete development. Gently bathe the image constantly with the hot water. When development is complete, transfer the matrix to a bath of cold water, and from there to a bath of

2% potassium alum. Then remove it and hang it up to dry in a stream of warm air. When the matrix is perfectly dry it can be stored for future use or printed straight away.

Print production To make prints efficiently by the dye transfer process requires adequate working space, including a sink and transfer area. A number of dishes will be required, dependent on the number of matrixes to be printed at any one time, varying from four when only a single dye transfer is to be made, to seven for a tricolour print.

Condition the dye transfer paper and eliminate any loose gelatin specks along the edges. First, rinse the paper in fresh running water for thirty seconds, then immerse it emulsion-side down in a dish containing Kodak dye transfer paper conditioner, and agitate periodically. Leave the paper in this solution from ten minutes to two hours.

The next stage is to expand the matrixes. Soak them for one minute or more in an individual dish filled with water at 38–50C (100–120F). After this soaking drain the matrix and place it in a working strength dye solution in which it is left for at least five minutes at room temperature. Then remove it from the dye bath and place in the first acid rinse, a 1% solution of glacial acetic acid. Agitate for one minute before draining and place in the second acid rinse. Discard the first acid rinse solution after use.

Place the matrix in a larger dish filled to about three-quarters of its depth with a 1% acetic acid solution. Lift and reimmerse at least twice to wash off the first acid rinse solution adhering to the surface of the matrix. This second acid bath is, in fact, a 'holding bath' as the matrix is left in it for a time ranging from thirty seconds up to several minutes, giving time to allow the transfer paper to be positioned on the transfer surface.

This transfer surface is either a large piece of plate glass on which the transfer paper is first placed or a more complex set-up for multiple registration by the use of a punch register system, similar to the system already fully explained in Chapter 1. When the images to be registered are fairly simple in shape such as derivated imagery, drop tone, outline, or solarized graphic effects, registration can be achieved by simple visual positioning as the matrix is transparent.

After placing the transfer paper onto the glass surface, it is squeegeed firmly to remove excess paper conditioner and to prevent bleeding of the dyes. Sponge off the transfer surface around the paper with a sponge dampened with 1% acetic acid.

Remove the matrix from the second acid rinse and place it onto the dye transfer paper quickly, squeegee into contact by holding one end of the matrix down onto the paper by the use of a heavy weight or clamps. The matrix image must not touch the transfer paper surface. The matrix is then squeegeed gently but firmly onto the paper by one sweep of the squeegee. Alternatively, the Kodak master print roller of

a size larger than the width of the matrix can be used for this step.

The matrix should discharge its dye image into the receiving paper in four to five minutes. Other matrixes can then be transferred, one after another, until the final image is printed.

Remove excess moisture from the surface of the print with a squeegee or windscreen wiper blade. Squeegee both sides of the print with firm strokes and immediately hang up to dry in a stream of hot air. Remember, rapid drying gives maximum sharpness. Clean the matrix after each printing by washing in clean running water for two or three minutes and hang up to dry.

For further information on this process, Kodak provide a technical booklet (E80) entitled *The Kodak Dye Transfer Process* which contains technological information for precise control of the process.

Other dyes and home-made gelatin coated papers work well when employed in a similar manner to the above process. The method is ideal for multiple printing and almost unlimited control can be exercised once the working procedure is mastered. Careful planning is necessary, as the process can go very wrong if a heavy handed approach is adopted.

EXPERIMENTAL SYSTEMS

Introduction The versatility of dyestuffs as image colourants offers an extremely attractive proposition for the experimentalist in offbeat imagery. Unfortunately, dyes quite often prove to be extremely difficult to control and work. They fade quickly when exposed to strong daylight, they bleed, migrate and run where often they have no right to be. Finally, chemical contamination, base material stain and susceptibility to marking during the processing cycle, all go to make up an image colourant that is at times very frustrating to use.

Essentially, the dye must be contained in a binder layer from which it should not be allowed to migrate. Therefore, any base material employed must be impervious to the dyestuff. It is easier said than done as it is the nature of dyes to stain almost anything. The few exceptions to this general rule are plastics and resin coated papers. Cibachrome papers for instance use an acetate base and most of the colour negative/positive processes employ resin coated papers, but base and binder stain still remain a minor problem even with these processes.

Oil/dye transfer The oil processes, as described in the section on pigment sunprinting, can be modified to print as a dye transfer system.

A positive transparency is used to expose the bichromated gelatin coated paper (see page 34) instead of the normal negative. A fairly stiff black ink is employed in the pigmentation. Once the resultant negative in oil-based printing ink has been manufactured, the oilprint is allowed to dry. The ink image must then be left for several days to thoroughly

dry out, preferably in a warm, dry atmosphere. The print could be pinned above a central heating radiator for instance. When dry, the ink image will act as a stencil or mask, and being oil based will strongly reject water based dyestuffs. On the other hand, the non-image areas which are left are composed of gelatin, a strongly water receptive substance. Therefore, the non-image areas are opposite to the negative image in oil and take up dye to show as a positive image. This can then be transferred onto another piece of gelatin coated paper, using the classic dye transfer system based on the Kodak process referred to earlier in this section.

The collotype process, as described in Chapter 2 can also be worked very successfully, giving an image of fine textural tonality in dye.

Exposure and inking are best judged by a trial exposure test strip. Full printing is often unnecessary as correct exposure is ascertained by dyeing the oil test strip and visually judging the image quality. The customary drying of the oil image need not be undertaken, thereby saving much valuable time at this stage.

Gum/direct dye Another pigment process can also be modified to produce images in dye. If dyes are included in the gum layer and printed normally, when the image is developed the water-based dye immediately dissolves out of the binder layer into the water. If the gum is coated without dye, then developed normally, fixed, rinsed, and is placed in a dye bath just before drying, the gum image will accept the dye. The small amount of residual bichromate left in the image acts as an efficient mordant. The gum layer must be coated onto resin coated paper after drying. When Kodak dyes are used, the gum image must be rinsed in a 1% solution of acetic acid before drying. Fabric dyes can also be employed. Cold water dyes are the most effective, no acid being required in the final rinse.

A negative is used to print this direct dye system and exposure is easily judged by visual inspection, just as in the original gum-bichromate sunprinting method. Multiple images are produced by giving successive coatings and exposure. Each image must be covered with a thin coating of clear varnish so that it is protected from the next dyeing stage.

Other dye systems Many other dye systems provide fodder for the creative experimentalist. Dye toning, for instance, where silver salt can act as a mordant, that is, a chemical compound which fixes a dye into an image layer or binder. Colour dye coupling—the processes which underlie most modern colour systems, could possibly also be exploited. Old books on photography often contain a great deal of information that can provide a starting point for further research and experiment. The creative sunprinter need not, of course, be an experimentalist, but this searching is highly enjoyable, even when processes prove to be

115

dismal failures. If successful, it helps to extend the visual vocabulary of the sunprinter, and in this way helps, in a small way, the overall development of creative print-making as a whole.

8. Mixed Media

Introduction This section deals with the vexed subject of mixed media. What is meant by mixed media? A dictionary definition of media is quite vague; media, which is the plural of medium, is described as 'that which lies in the middle, or an agency, a pretended intermediary between men and the spirits or gods.' Media as used in the modern world is a word that has come to mean sophisticated methods of human communication. The printed word, television, radio, the film, audio cassette and disc, graphic and advertising design, all are said to be media. Oral means of communication are also deemed to be media, particularly if associated with the visual image as in TV and movies.

This while area is fantastically complex as society moves through the electronic age into the era of photonic holography and multichannel television. Great social changes are bound to follow. But this book is primarily concerned with the two dimensional world of the sunprint, of low technology and the expansion of individual consciousness. The necessary philosophy to deal with futuristic high technology is best left to the sociologists such as Marshall McLuhan whose brilliant treatise *Understanding Media* investigates and offers an approach to this type of problem.

Mixed media in this book is defined as 'still, two-dimensional image making' where a mixture of visual images from diverse sources are brought together by means of a creative act of will on the part of the sunprinter, in an attempt to create new and exciting examples of visual expression.

The previous sections in this book have, it is hoped, fired the sunprinter with enough enthusiasm to try and bring together all the various ingredients of the book. Having mastered tone, colour and autographic applications, the next logical step is to apply this methodology, using material coated with light-sensitive emulsions, made possible by the pigment, metal and dye methods of sunprint-making.

The problem is where to start. The computation of the variables

117

which are possible is indeed immense; quite offputting to the beginner. When in doubt start simply and gradually make the image more complex. Know why each modification is to be made before starting the work.

The creative sunprinter is in essence an image-maker whose function is to devote as much time and energy as possible to the development of a personal vision. The very broadness and creative potential of mixed media allows totally different personal styles to evolve. This freedom makes sunprinting as flexible a medium as any of the classic methods of fine art print-making.

Sources of illustration John Berger comments, in his controversial book on art criticism *The Ways of Seeing*, how modern reproduction of real images and the artifice of commercial advertising propaganda dramatically change our concept of the nature of the image-making process. To see two colour images side by side on the same magazine page, one of a starving child and the other showing some artificial sexual fantasy advertising a box of chocolates, provides a bizarre comment on modern visual literacy. However, this interaction of imagery is not always detrimental. John Berger goes on to comment that adults and children sometimes have pin boards in their bedrooms or living rooms on which they pin pieces of paper, letters, newspaper cuttings, original drawings, postcards etc.

On each board all the images belong to the same language and all are more or less equal within it because they have been chosen in a highly personal way to match and express the experience of the room's inhabitant. Logically, these boards should replace art galleries and museums.

This pin board method of gathering images is an extremely useful way of bringing images together from the debris of day to day living. Once these images begin to work against each other, they can be transferred to a scrapbook to await the final transmutation into a sunprint.

Another way in which the sunprinter can exploit mixed media is to take a more objective view of a subject or theme which deeply moves or interests him. A wide, general theme should be sought; the human face, landscape, still life, social or political issues, all provide a potential lifetime of visual study. As the material slowly amasses from various sources, each new image will help define the previous images and provide a stimulus for further experimentation.

The human face has for obvious reasons provided inspiration and subject matter for the portraitist, sculptor and photographer. A theme of this nature would not be ideal as a preliminary project, the scope being far too broad. A more viable initial approach to this theme could be to take one aspect of it, for instance the *constructed* human face. Suitable subject matter immediately springs to mind—masks, puppets,

118

manikins, sculpture, carnival figures, ship figureheads etc. The imagery quickly begins to build up, providing more than adequate fuel for the creative act of sunprinting.

The sources from which material may need to be obtained are almost as numerous and diverse as the research material itself. Public museums, galleries, libraries and archives, have available vast collections of fairly low cost material.

Two comprehensive guides for the visual researcher are, first, *Picture Researcher's Handbook* by Hilary and Mary Evans and Andra Nelki and secondly *Sources of Illustration* by Hilary and Mary Evans. Both these books are worth their weight in gold to the avid researcher, saving much time and sweated labour. Particularly useful when a specialist source of material is required, these books also shed light on the troublesome problems of copyright, rates, credits and the role and responsibilities of the picture researcher. Although they are primarily aimed at the professional picture researcher, they should prove invaluable to the creative sunprinter contemplating mixed media presentation.

METHODS

History Almost from the birth of photography the artist began to interfere with the photographic image. The famous portraitist David Octavius Hill of the Hill and Adams partnership, blatantly used photographs as a basis for a painting to commemorate the separation of the Scottish Church from the Presbyterian Church.

Early methods of mixed media were used for purely commercial considerations. The addition of handpainted colour made the photograph highly attractive to a public avid for portraits. Oil painted photographs were regarded with favour because they were less expensive than original oil paintings and did not require tiresome sittings on the part of the subjects.

The Cliché-Verre process, which produced a print rather similar to an etching, was introduced in the 1850s and became popular. A Cliché-Verre print was made by covering a piece of clear glass with an opaque coating such as a dark varnish. Through this coating the artist would inscribe a linear picture with a sharp instrument. This handmade negative was then contact printed onto photosensitive paper, usually silver salted paper. The rationale underlying this process was the bypassing of the involved craft routine needed to make intaglio prints on copper or lithographs on stone.

A modified form of the Cliché-Verre is easily adapted to sunprinting. A sheet of glass or plastic is coated with photopake, scratched with a needle, then printed. An alternative is to use a smoked piece of glass or plastic. A candle or small paraffin lamp is a useful aid in the smoking.

119

Beware of unevenly heating the glass as it can shatter. The smoked material has other uses apart from being scratched. If pure turpentine is dropped from a height onto the plate, very graphic images result. Photographic film itself provides a base for the Cliché-Verre technique. Fog the film and develop it until it is a uniform black. Fix, and while still wet, scratch with a fine sharp needle. Any of the sunprinting methods already outlined in this book can be successfully applied to this process.

Multiple image The photomontage or multiple image did not gain artistic respectability until the late 1920s when a remarkable innovator, Laszlo Moholy-Nagy, the Hungarian born Bauhaus teacher, constructed a number of manipulated images where he juxtapositioned photographs of three-dimensional objects and people with drawn flat forms. These surreal images, effectively opened the door for the painter, printmaker, sculptor to use the photograph as a component in mixed media presentation. The Bauhaus was a highly original school of art which came to terms with the relationship between art and the modern industrial society.

The multiple image introduces a number of problems, some technical, others aesthetic. The main technical difficulties centre around the physical methods by which the images are assembled. The cut-out, photomontage or collage are the simplest methods. With the cut-out, the images are cut out with sharp scissors and stuck down with adhesive.

Collage The collage differs from the montage as usually a collage consists of a mixture of subject material—newspaper cuttings, cloth, packaging, match box, photographs—in fact just about anything related to something else. The collage is quite often partially three-dimensional in character, more a kind of sculpture than a flat two-dimensional representation.

Photomontage The montage on the other hand tends to be more or less two-dimensional. If entirely photographic in character, the joining of the various picture elements is carefully disguised so as not to show where one image joins another. This effect is achieved in two ways, firstly by carefully chamfering the edges of the images so that when they are stuck down, the image edge literally merges into the surface of the adjacent print. The second technique is to cut the edges of the images making up the photomontage in such a manner that they follow natural straight lines or textured edges in the picture. The montage is then carefully copied and retouched, special attention being paid to obvious image inconsistencies, such as the matching of two adjacent tones and the camouflaging of edge shadows and lines. The photographic copying stage in this process helps to obscure the joins and print retouching.

120

Between the first and second world wars this technique was used to great effect by pictorialists such as F J Mortimer, and by Charles Wornald in the development of early advertising photography. This technique allowed effects to be produced which were impossible with the cumbersome contemporary photographic equipment, and in the hands of a master, the final result is almost indistinguishable from an original photograph.

Although this method of working required great manipulative and technical skill, the finished results often did not live up to expectation. However, photomontage can be very powerful in the hands of an original creative genius such as Jerry Uelsmann who specializes in landscape fantasy, or J Heartfield who made the surreal montage a vehicle for powerful anti-fascist political comment. It is not being used as a second form of reality, but for its own unique surreal quality and it produces a lively and vibrant picture.

Rough cutting-out of the images is often far more effective than more careful work. The image edge has its own visual dynamism. It has an honesty which adds rather than subtracts from the final image. An excellent example of this effect is the portrait by Arnold Newman of Andy Warhol which shows a mask of Andy's face overlayed by yet another mask of Andy's face.

Multiple exposure A further multiple image technique is to expose a number of images one after another in the camera. Although quite possible, this method of working is extremely complex and, therefore, difficult to control. A much simpler camera technique is to use the projected slide, either monochrome or colour, as a starting point. A multiple image is built up on a projection screen by the use of several slide projectors until a satisfactory picture is created. This projected montage is then rephotographed—a simple and effective system which allows considerable manipulation at the same time as being fairly simple to achieve.

Masks Contact printing masks, whether hand-drawn or photographic, enable a very sophisticated assemblage technique to be used. Silver masks provide the most efficient systems but they are, of course, expensive. The autographic mask, on the other hand is quite cheap and surprisingly easy to produce. An accurate registration technique is essential for the successful operation of this system of multiple image assemblage. This type of registration system has been previously described in the photographic preparation section (page 18) and should prove perfectly adequate for multiple printing at this stage.

Image copying Photographers often become obsessional about image or print quality. This attitude of mind is perfectly understandable when one considers the fundamental nature of the photographic process.

121

Image definition and tonal quality suffer at each stage of reproduction. A progressive breakdown of image quality occurs and some tonal definition is destroyed. Continuous copying of a photograph will eventually produce, after dozens of lens/film stages, a pure piece of black, white or grey paper with little or no image present. But, during the transformation of the image, strange effects take place. If the multiple image is slowly built up, lens/film stage by lens/film stage, one image will blend into another causing new and exciting relationships to emerge.

Reprographic systems offer a relatively cheap and fast way of exploiting these metamorphic changes in image content and structure. Each system has its own particular set of image transformation qualities that can be coupled together or used separately. A good exercise to test this phenomenon is to use, say, a library copier and place several picture post cards on it. Reproduce these cards ten times, each copy being used as the starting point for the next one. The images will gradually disappear until when about the tenth copy is produced, little or none remains. These minimal images are curious and extremely exciting as they lie on the border of visual recognition. These pictures are strangely disturbing as more feeling seems to be conveyed by the image, although less is plainly seen.

Fine art prints, etching, lithographs and relief prints, such as lino and wood cuts supply a useful source of material for image making, particularly old prints which are still available quite economically in junk and bric-a-brac shops. These old prints have the feel and smell of history. Old book illustrations have a similar quality.

Fotage Robert Rauchenberg, the celebrated post-war American mixed media painter, developed early in 1950 a technique of image transfer known as fotage. Magazines or other printed matter are sprayed with solvents such as turpentine or paint stripper, then placed face down in contact with a piece of paper, and the back of the magazine is rubbed down hard with a wooden spoon or hard lino roller. The image in the magazine then transfers onto the paper. Quite often these image transfers appear distorted and the colours run into each other, image definition is seriously impaired and a dramatic reduction in quality occurs. But the images have a mysterious haunting effect as if the corrosive quality of time itself is, for a fleeting second, captured. These smeared images offer an interesting starting point for further experimental work.

The derivated graphic image, solarization, drop tone, posterization, distortion, line edge effects, all lend themselves to highly graphic image production. The breaking down of the image into simple graphic shapes, then the rebuilding into more complex images by a process of multiple assemblage follows the classic pattern of mixed media presentation. Therefore, this type of picture construction fits in very easily with the various methods already described and adds yet another dimension to

creative sunprinting. An excellent book on photographically derived images is *Creative Photographic Printing Methods* by H C Woodhead (*Focal Press.*)

Conclusion The technical problems associated with mixed media pale into insignificance when compared to the aesthetic possibilities.

In terms of the history of art, photography is of very recent origin as a picture making process, only four to five generations old. Our great grandfathers were the first human beings to use this vital and energetic medium.

During this period photography has had to come to terms with a massive explosion and revolution in all the arts. Aaron Scharf and other leading art historians have put forward the view that these changes in the art aesthetic were partially due to the emergence of photography, which immediately took over many of the legitimate functions of the artist, both socially and commercially. It is not for nothing that Eugene Delacroix exclaimed 'From this day forward, painting is dead' in the early 1850s.

Many of the modern movements in art have used the photographic image as a starting point for further development. The surrealist movement defined as works of art those in which the unexpected is confronted by the impossible. They found the mirror-like reality of the photograph a powerful tool in depicting surrealist themes.

Paul Nash, a celebrated English landscape painter who used a simple Kodak box camera, was so impressed by the photograph that he wrote a book, *The Fertile Image*, describing how photography depicted hidden meanings in subjects, such as tree roots, stone megaliths, the movement of water and the growth of plant life. All these subjects were seen by Paul Nash as mysterious sources of visual energy, where one universe impinged upon another in the same, or similar, spatial planes. He was one of the few notable pre-war landscape painters to publicly align his painting to the photographic medium. Most painters of his day, although quite often using photography as source material, were surprisingly reticent about their use of it, feeling perhaps somewhat ashamed, conditioned by earlier opinion. However, today most modern painters see photography as no more nor less than an extension of their own personal development as artists. This healthy attitude is of immense help to the creative photographer who has still a great deal to learn from the painter. In fact, all art is symbolic, each living off the other. Gombrich has quoted in his book *Art and Illusion*: 'Art does not exist in nature, only in the artist'.

The degree to which painters were influenced by photography in the recent past is excellently illustrated in a book entitled *The Photographer and the Painter* by Coke. The relationship between photography and other art forms is symbiotic rather than parasitic, each giving to the other, to the mutual advantage of all. This form of cooperation is

extremely valuable. Painting, for instance, can exist without photography, indeed it has done so for many hundreds of years. On the other hand, there is enough scope implicit in photography to make it independent of fine art or painting. Sunprinting forms a natural bridge between the two being partially autographic, although at the same time mainly photographic. As the process requires a good deal of personal control it has greater creative potential than conventional photographic printing methods in the whole breadth of the visual arts. The creative act is similar to the growth of a plant or flower, the right environment is essential just as the correct amount of light, heat and moisture and the right soil are essential for the healthy growth of a plant. We must also not overlook the achievements of the past. Creative activity must, in essence, be a learning process.

To conclude this section on mixed media and creative sunprinting as a whole, the words of Arnold Newham immediately spring to mind. When interviewed recently in a BBC television series, *Exploring Photography*, he made this statement about his personal approach to this work: 'I work the way I do because its the kind of person I am. The way I think, the way I feel, the way I react, my style is the result of me being me. We are each individuals and you have to seek your own style in your own way. In order to become a creative person you must first find yourself, not try and imitate someone else, otherwise all we will have is imitations.'

Suppliers

Supplies in small quantities of any unusual material or product have become more and more difficult to obtain. Gone are the days when you could obtain loose chemicals from the chemist, and a variety of paper from the stationers.

'Almost Photography Supplies' has been set up by the author of this book to offset this lamentable trend. It is hoped to supply small quantities of basic materials suitable for working any of the sunprinting processes described in this book. Eventually, a range of equipment and kits for the various processes will also be offered for sale.

REFERENCE BOOKS

Handbook of Printmaking Supplies by Silvie Turner, Printmakers Council, London 1977, provides a very comprehensive guide to most of the requirements for obtaining materials and equipment.
Pigment Printing Processes by Ti Williams, published by the Royal Photographic Society, gives excellent advice on paper, inks and pigments, gum gelatin, PVA, brushes and suitable photographic material.
Industrial and Commercial Photographer's Directory and Buyer's Guide 1979 gives some useful information on products and materials.

PAPER

Paper has a profound effect on the nature of a sunprint, therefore, it must be chosen with care. A paper is needed that is tough, with good wet strength and able to return to almost its original dimensions, when it is dried again.

Handmade paper more nearly fulfils these requirements than machinemade, but, of course, it is much more expensive. Each sunprinting process demands differing qualities from a paper, therefore, personal

experimentation will probably be needed to find the paper that exactly suits the process and the printer.

The purchase of paper which is too thin often proves to be a false economy, as very thin papers damage extremely easily. Paper thickness is known as the weight of a paper and is judged the number of grams per square metre (gsm). Artists' paper is usually sold in sheets of imperial size (about 30 × 32 in) and a weight of about 300 gms and makes a useful stiff paper. Old or waste photographic prints make excellent base material, as the paper is usually of very high quality. The photographic image is removed from the gelatin emulsion coating by bleaching with the classic iodine reducer. Both the silver image and gelatin emulsion are easily removed by the use of a domestic bleach. The paper must be very thoroughly washed after this treatment to remove all the bleach.

Most local artists' supply shops hold a reasonable stock of paper.

Almost Photography (Supplies), 9, Cranley Road, Westcliff-on-Sea, Southend-on-Sea, Essex.

Paper, pigment inks, gums, gelatin, chemicals and general sunprinting supplies.

Barcham Green & Co. Ltd., (Simon Green), Hayle Mill, Maidstone, Kent ME15 6XQ. 0622–674343.

Handmade papers only. Will sell direct to purchaser in quantities over one quire (24 sheets). Sample booklets are available on request with price lists. Range of sizes available and facilities and expertise for special 'makings'. Initiation of paper museum and printing workshop at the mill. Also the firm E. Amies is situated in part of the mill making moulds and deckles.

R. K. Burt, 37, Union Street, London, S.E.1. 01–407 6474.

This firm is the sole distributor of Arches and Rives papers in the U.K. Also stocks Saunders, Bockingford and R. K. Burt Mouldmade, acid free tissue and a range of machine made papers. This firm will supply their mouldmade papers in multiples of 25 sheets.

Graphic Chemical Co. Ltd.,
P.O. Box 27 AC,
728, North Yale Ave,
Villa Park,
Illinois 60181.

Inks, materials, and paper.

E. C. Lyons,
16, West 22nd Street,
New York,
NY 10010.

General supplies including paper.

Paper Chase,
216, Tottenham Court Road,
London, W.1.
01–637 1121.
or
67, Fulham Road,
London, S.W.3.
01–589 7873.

Small selection of Japanese and handmade papers otherwise mostly machine made and boards.

Paper Point,
63, Poland Street,
London, W.1.
01–439 4414.

Only small amounts of paper are sold at the shop but they will indicate where larger orders should be placed.

Reeves and Sons Ltd.,
13, Charing Cross Road,
London, W.C.2.
01–930 9940
or
178, Kensington High Street,
London, W.8.
01–937 5370.

Selection of hand and machine made papers.

G. Rowney & Co. Ltd.,
12, Percy Street,
London, W.1.
01–636 8241.

Main retailers and distributors for Fabriano paper, plus range of hand and machine made.

Winsor & Newton Ltd.,
51, Rathbone Place,
London, W.1.
01–636 4231.

Selection of hand, mould and machine made papers.

INKS AND PIGMENTS

The terminology surrounding inks, paints, dyes and pigments is confusingly vague. This terminology usually means a colourant which is a dye or pigment suspended in a binder or vehicle, the combination of colourant and binder being the ink, dye or paint.

For the purposes of sunprinting the pigment or dyestuff is usually in the form of a powder. The binder is either water based, such as watercolour, gouache or PVA colours; or oil based as in lithographic ink, letterpress, etching or artists' oilcolour paints and inks. Once again, these materials will have to be selected with considerable care to accurately fit the process. Dyes, of course, just use water as a binder or vehicle.

Almost Photography (Supplies),
9, Cranley Road,
Westcliff-on-Sea,
Southend-on-Sea,
Essex.

Paper, pigments, inks, chemicals and general sunprinting supplies.

American Graphic Art Inc.,
628, West 46th Street,
New York,
NY 10036.

General litho and ink supplies.

California Ink Co.,
501 15th Street,
San Francisco,
CA 94103.

Inks and chemicals.

Croda Inks Ltd (Accounts),
119, Western Road,
London, SW19 2QA.
01–640 7611.
or
A. Gilby & Sons Ltd.,
(Croda Polymers Group),
Reliance Works,
Devonshire Road,
Colliers Wood,
London, S.W.19.
01–542–5262.

Inks, mainly commercial, metallic and fluorescent.

128

Hunter-Penrose Ltd.,
7, Spa Road,
London SW16 3QS.
01–237 6636.

Suppliers of all materials for photo and autographic litho plates, drawing and processing materials etc. Good discounts for schools and colleges on certain items.

W. H. Korn Inc.,
260, West Street,
New York,
NY 10013.

Litho, crayons, pencils, inks and materials.

Litho Chemical & Supply Co.,
46 Harriet Place,
Lynbrook,
NY 11563.

General litho supplies.

Mander Kidd (UK) Ltd.,
1, Bashley Road,
London, N.W.10.
01–965 2141.

Inks.

John G. Marshall Mfg INC.,
167, N 9th Street,
Brooklyn,
NY 11211.

Marshall photo oils, protective and toothing lacquers.

McDonald Photo Products Inc.,
2522, Butler,
Dallas,
TX 75235.

Retouching lacquer oil pigments.

W. R. Nicholson,
14, Wates Way,
Mitcham,
Surrey.
01–640 4236.

Litho materials and photo supplies.

Michael Putman,
151, Lavender Hill,
London, S.W.1.
01–228 9603.

Stockist of Arches, Rives, Saunders, Bockingford, Fabriano, etching and selection of machine made papers. Also a large selection of inks.

Peerless Color Laboratories, 11, Diarnond Place, Rochester, NY 14609.	Transparent water colours.
Winstones, Park Works, Park Lane, Harefield, Middx. 01–420 3171.	Autographic inks.

EQUIPMENT

Most of the general equipment needed can be obtained from hardware stores or local decorating shops, the only specialist equipment being contact printing frames and a press for oil transfer work. This latter item is easily made by converting a wooden roller from an old mangle. Such mangles are still to be found in junk shops and yards. The wooden rollers are best covered in metal tubing, and provide a very efficient and cheap press. Contact frames are easily made by the average do-it-yourself carpenter.

Garo Z Antesian, Tamarind Institute, University of New Mexico, Albuquerque, New Mexico 87106.	Presses, litho, quarterly review.
Charles Brand, 84, East 10th Street, New York, NY 10003.	Large range of presses and sizes.
Challenge Machinery Co., Grand Haven, Michigan.	Proofing and hand presses.
Colebrook, Evans and McKenzie, 5, Quality Court, Chancery Lane, London WC2 AHP. 01–242 1362.	Auctioneers for sales of printing equipment.

Chris Holladay, Belsize Mews, 27, Belsize Lane, London, N.W.3. 01–794 7954.	Secondhand presses, maintenance, removals, plus equipment—aquatint boxes, hot plates, etc.
The Griffen Co., 2241 6th Street, Berkeley, CA 94710.	Litho presses.
Hunter-Penrose, 7, Spa Road, London, S.E.16. 01–237 6636.	No. 8 is a popular press. Also manufacture students' and small presses, manual or motorized, and numerous other items of equipment.
Littlejohn Graphic Systems Ltd., 16–24, Brewery Road, London N7 9NP. 01–607 6681.	Printing down frames, light sources, processors, etc.
Modbury Engineering, Belsize Mews, 27, Belsize Lane, London, N.W.3. 01-794 7954.	Removals, services, secondhand presses, ancillary equipment.
Naz-Dar Company, 1087, N North Branch Street, Chicago, IL 60622.	Screen printing equipment.
Rotaprint Ltd., Rotaprint House, Honeypot Lane, London NW9 9RE. 01–204 3355.	Plates, chemicals, sundries, sink units, inks, printing down frames.
Treck Photographic, 1919, S E Belmont, Portland, OR 97214.	Premier contact printing frames.

PHOTOGRAPHIC MATERIALS

Normal photographic supplies can usually be obtained from local photographic shops, but when unusual specialist materials are required, it is best to use the retail sales counter of the manufacturing company.

Almost Photography (Supplies),
9, Cranley Road,
Westcliff-on-Sea,
Southend-on-Sea,
Essex.

Normal photographic items plus specialist material suited to sunprinting.

Autotype U.S.A.,
501 West Golf Road,
Arlington Heights,
IL 60005.

Photographic dye transfer materials and dyes.

Du Pont de Nemours E. I. & Co.,
Wilmington,
Delaware 19898.

Litho type films and clearbase films.

Eastman Kodak Company,
Rochester,
New York 14604.

Halftone contact screens and litho films.

Elegant Images,
2637, Majestic Drive,
Wilmington,
Delaware 19810.

Platinum and palladium printing packs and materials.

Free Style Sales Co. Inc.,
5124 Sunset Blud,
Los Angeles,
CA 90027.

Small quantity packaging or large sheet ortho film mail order.

Dr Robert Green,
Carbon Gallery,
614 Fort Wayne,
IND 46222.

Carbon and carbro materials and equipment.

Hunter–Penrose Ltd.,
7, Spa Road,
London, S.E.16.
01–237 6636.

Large range etching supplies, including photosupplies, acids.

Ilford Ltd., Basildon, Essex SS14 3ET. Basildon 27744.	Photographic supplies.
Kentmere Ltd., Kentmere, Staveley, Cumbria LA8 9PB. Staveley 821365.	Photographic papers.
Kodak Ltd., Marylands Avenue, Hemel Hempstead, Herts. 0442–2191.	Photographic supplies.
Leeds Camera Centre Ltd., 16, Brunswick Centre, Bernard Street, London, W.C.1. 01–837 8030 and 8039.	Photographic equipment and supplies.
Ozalid Ltd., Langston Road, Loughton, Essex 1G10 3TH. 01–508 5544.	Diazo products.
Ozalid Reproduction Products, Division of the General Aniline and Film Corporation, 25, Ozalid Road, Binghamton, New York 13903.	Diazo products.
3M Company, Printing Products Division, 3M Center, St Paul, MN 55101.	3-M colour key and transfer key products.
3M UK Ltd., 3M House, Wigmore Street, London W1A 1ET. 01–486 5522.	Plates, chemicals, sundries, films, processors, etc. (See also Reprographics.)

Pelling & Cross Ltd.,
104, Baker Street,
London, W1M 2AR.
01–487 5411.

Photographic equipment and supplies.

CHEMICALS

Safety is extremely important when handling chemicals. Rubber gloves are essential when handling many chemicals and personal hygiene should be strictly adhered to. Photographic manufacturers at one time used to hold large stocks of chemicals, but today they only hold the minimum, therefore, they are not included in this list of suppliers.

Almost Photography (Supplies),
9, Cranley Road,
Westcliff-on-Sea,
Southend-on-Sea,
Essex.

Chemicals in small quantities.

Agfa-Gevaert Ltd.,
27, Great West Road,
Brentford,
Middx. TW8 9AX.
01–560 2131.

California Ink Company,
501, 15th Street,
San Francisco
CA 94103.

Inks and chemicals.

Cerulean Blue Ltd.,
1314 NE 43rd Street,
Seattle,
WA 98105.

Dyes and related chemicals.

D.Y.E. Textile Resources,
8763, Durango Avenue,
Los Angeles,
CA 90034,

Dyes, blue print and Van Dyke process chemical kits.

Eric Fishwick Ltd.,
Grange Road,
Haydock St. Helens,
Merseyside WA11 0XE.
St. Helens 27384/5/6.

When in stock, will deliver by return of post.

May & Baker,
Rainham Road South,
Dagenham,
Essex RM10 7XS.
01–592 3060.

Nurnberg Scientific, Chemicals and laboratory
6310 SW Verginia Avenue, supplies.
Portland,
OR 97201.

Photo Technology Ltd.,
9, Cranborne Industrial Estates,
Potters Bar,
Herts. ENG 5ES.
Potters Bar 50295.

Pictograph Ltd., Graphic arts chemicals.
Stockbury Works,
181, Victoria Road,
New Barnet,
Herts. EN4 9PN.

Rayco Instruments Ltd.,
Blackwater Way,
Ash Road,
Aldershot,
Hants. GU12 4DH.
Aldershot 22725.

Summary of Processes

GUM-BICHRO PROCESS

(1) Prepare print material—if necessary size with gelatin, arrowroot, or PVA.

(2) Dampen and place print material on sheet of glass. Squeegee off all surplus water until damp dry.

(3) Mix gum coating:

Ammonium bichromate 10% solution	1 level spoonful
Office gum or 50% solution gum arabic	1 ,, ,,
Water colour pigment from tube	½ in
or dry powder pigment	¼ level ,,

Mix ingredients until a smooth mucilage, the consistency of single cream, results. This amount should be sufficient to coat two 20×25cm (8×10in) sheets of paper.

(4) Brush mixture onto print material with a household paint brush.

(5) Smooth with dry roller until an even coating results.

(6) Hang up to dry in a stream of hot air in weak artificial illumination or bright safelighting.

(7) Place dry coated material in contact frame with the negative and expose until a strong print-out image appears.

(8) Develop in clean water by soaking for 15 to 30 min or use the faster water hose or buckle brush techniques.

(9) Fix in a 5% solution of acid hardener until colour clears.

(10) Rinse in clean water and hang up to dry. When dry the process is complete. However, further multiple printing can take place, but the print material must be resized before commencement.

CARBON TISSUE MANUFACTURE

(1) Mix tissue coating:
Gelatin (Nelsons No. 1 or domestic)
dry powder 6 level spoonfuls
Cold water 110 ml
Soak gelatin in cold water for two hours, then gently warm until
a temperature of 38–43C (100–110F)
Now add:
Glycerine 1 level spoonful
Sugar 1 ,, ,,
Dry pigment powder 4 ,, ,,
Thoroughly mix to form a syrupy solution. Do not overcook either
in time and/or temperature.
(2) Dampen and place tissue paper base material on coating frame
base and squeegee off all surplus water.
(3) Position coating frame on base and clamp with gee clamps or
bulldog clips.
(4) Pour mixture into coating frame until half full, then immediately
pour back into jug.
(5) Place frame in a level cool position and leave to set.
(6) When set, remove tissue from coating frame and hang up to dry
in a stream of warm but not hot air—27C (80F) maximum.
(7) Dry tissues can either be stored for future sunprinting or sensitized
and used straight away.

CARBON PROCESS

(1) Prepare final support. Coat with gelatin or fixout photographic
paper in a plain non-hardening fixer such as 20% solution of
sodium thiosulphate. After fixation, wash for 1 hour in fresh
running water.
(2) Mix spirit sensitizer—approximately 3%:
One part 10% solution ammonium bichromate.
Two parts denatured alcohol or methylated spirit.
(3) Place final support material in a dish of clean cold water.
(4) Place carbon tissue in dish containing spirit sensitizer for 2
minutes or use buckle brush.
(5) Place tissue face down on a sheet of glass and squeegee off all
surplus sensitizer. Gently remove any sensitizer on face of tissue
with chamois leather. The tissue is easily damaged at this stage
so go gently.
(6) Hang tissue up to dry in a stream of hot air in weak artificial
illumination or bright safelighting.

(7) When dry, place tissue in contact frame with the negative and expose. Use actinometer or test strip to determine correct exposure.

(8) Place exposed tissue in dish containing final support material. When tissue half uncurls, bring into contact with final support face to face.

(9) Remove tissue and final support, place on sheet of glass and lightly squeegee together.

(10) This pack is now placed between blotting boards and light pressure applied by positioning a pile of books on top. Leave for ten to twenty minutes.

(11) Immerse the pack in a dish of hot water at a temperature of 38–43C (100–110F).

(12) When pigment begins to ooze out around the edge of the pack, strip the tissue of the final support and discard.

(13) Gently splash image with hot water until it clears of all soluble pigment.

(14) Place in fixer 5% solution acid hardener until colour clears.

(15) Hang up to dry in a stream of warm air.

OIL PRINTING PROCESS

(1) Prepare print matrix material—coat with gelatin as described under carbon tissue manufacture or fix out photographic paper in a plain non-hardening fixer such as 20% solution of sodium thiosulphate. After fixation wash for one hour in fresh running water.

(2) Mix spirit sensitizer:
One part 10% solution ammonium bichromate.
Two parts denatured alcohol or methylated spirit.

(3) Dampen and place print matrix material on sheet of glass. Squeegee off all surplus water until damp dry.

(4) Sensitize with a pad of chamois leather soaked in sensitizer. Move this pad across the surface until an even yellow/orange colour results.

(5) Hang up to dry in a stream of hot air in weak artificial illumination or bright safelighting.

(6) Place dry sensitized material in contact frame with the negative and expose until strong print-out image appears.

(7) Develop in cold fresh running water until all the yellow bichromate stain disappears and the shadow areas take on a green/grey colour.

(8) Hang up to dry in a stream of hot air until bone dry.

(9) Mix print conditioner:
One part glycerine.
Two parts water.
5% ammonia.

(10) Soak print matrix material for 15 to 30 min in the conditioner. Timing is dependent on initial exposure. After processing, bottle conditioner for future use.

(11) Place print matrix material on sheet of glass and very gently squeegee off excess conditioner so that the surface is damp but not wet. No free conditioner should be on the surface, or uneven pigmentation will result.

(12) Place a dab of litho ink on a second sheet of glass and charge up the bromoil brush with it. Make sure the brush holds the minimum of ink.

(13) Dab the brush lightly onto the print in a pressing, smudging movement. When an image begins to appear work over the print again and again until a fairly strong image is present. Finish off the print with a dry brush or foam roller, which will remove the surplus ink and bring the print into the correct tonal condition. At this stage, the oil image can be offset onto any other surface by the use of an etching press.

(14) Hang up to dry. This process will take from one to three days, to allow the litho ink to dry.

SILVER PROCESS

(1) Mix sizing solution:

Ammonium chloride	1 level spoonful
Arrowroot	2 ,, ,,
Distilled water	280 ml

Mix arrowroot into a smooth paste with a very small amount of water, then warm the remaining water, adding the ammonium chloride in a separate pyrex jug. Slowly add the arrowroot paste, stirring until a clear jelly is formed.

(2) Brush this jelly into the fibres of the paper with a blanchard brush and hang up to dry. Then apply a second coat and dry.

(3) At this stage the sized paper can be stored or sensitized immediately.

(4) Mix sensitizing solution:

Silver nitrate	3 level spoonfuls
Distilled water	280 ml

Mix in weak artificial illumination or bright safelighting.

(5) Pin sized paper to drawing board with plastic headed pins or masking tape.

(6) Apply silver sensitizing solution to the surface of the sized paper with the aid of a buckle brush.

(7) Hang up to dry in a stream of hot air under weak artificial illumination or bright safelighting.

(8) Place sensitized paper in contact frame with negative and expose until a slightly too dark print-out image appears.

(9) Immerse in a 5% solution of sodium chloride until no milkiness in the highlights remains, then wash for a further 10 minutes.

(10) Mix gold toning bath:

Chlorauric acid	15 grain tube
Borax	2 level spoonfuls
Water	850 ml

(11) Immerse print in toning bath and leave until shadows become purple black in colour.

(12) Rinse in 1% solution of sodium chloride.

(13) Fix in 5% sodium thiosulphate and wash for fifteen minutes.

(14) Hang up to dry in a stream of warm air.

IRON PROCESS—BLUEPRINT

(1) Prepare unsalted sized paper:
Mix sizing solution:
Two level spoonfuls of arrowroot dissolved in 280 ml of distilled water.
Mix and coat in the same way as the sizing of the silver paper.

(2) Mix sensitizing solutions A and B:

(A) Potassium ferricyanide	5 level spoonfuls
Distilled water	55 ml
(B) Ferric ammonium citrate	5 level spoonfuls
Distilled water	55 ml

Mix one part of A with one part of B—discard after use. Store working solutions A and B in dark bottles.

(3) Pin sized paper to drawing board with plastic headed pins or masking tape.

(4) Apply blue print sensitizing solution with buckle brush in weak artificial illumination or bright safelighting.

(5) Hang up to dry under safelight conditions, preferably with the use of radiant heat.

(6) Place sensitized paper in contact frame with negative and expose until a print-out image appears.

(7) Develop in fresh running water until highlights clear.

(8) Fix in water bath containing a few drops of hydrochloric acid.

(9) Hang up to dry.

IRON PROCESS—VAN DYKE BROWN

(1) Prepare unsalted sized paper as in blueprint process.
(2) Mix Van Dyke sensitizer:
Make up into solutions A and B and store in amber bottles.

 (A) Ferric ammonium citrate 20 level spoonfuls
 Citric acid 5 ,, ,,
 Water—distilled 280 ml
 (B) Silver nitrate 5 level spoonfuls
 Water—distilled 110 ml

Mix equal parts of solutions A and B to make sensitizer.

(3) Pin sized paper to drawing board with plastic headed pins or masking tape.
(4) Apply Van Dyke sensitizer with buckle brush in weak artificial illumination or bright safelighting.
(5) Hang up to dry under safelight conditions with the use of radiant heat.
(6) Place sensitized paper in contact frame with negative and expose until a slightly weak print-out image appears.
(7) Immerse print in weak borax developing solution from 5% to 10% for 5 min.
(8) Transfer to 20% solution of sodium thiosulphate (hypo).
(9) Wash in fresh running water for 30 min and hang up to dry.

IRON PROCESS—PLATINOTYPE

(1) Prepare paper base size, if necessary.
(2) Mix solutions (A), (B) and (C) and store in dark medicine dropper bottles. Very accurate measurement is required when undertaking this process.

 (A) Oxalic acid 1.1 gm
 Ferric oxalate 16.0 ,,
 Hot water 60 ml
 (B) Oxalic acid 1.1 gm
 Ferric oxalate 16.0 ,,
 Potassium chlorate 0.3 ,,
 (C) Potassium chloroplatinite 3.0 ,,
 Water 14 ml

(3) Mix the emulsion with the aid of a dark medicine dropper bottle into a small measuring jug.

For contrasty negatives—Solution A—22 drops
,, B— 0 ,,
,, C—24 ,,
For normal negatives — ,, A—14 ,,
,, B— 8 ,,
,, C—24 ,,
For soft negatives — ,, A— 8 ,,
,, B—14 ,,
,, C—24 ,,

Mix in low level artificial or bright safelighting.

(4) Heat dry paper, drawing board and contact frame so that they are warm to the touch.

(5) Pin paper to drawing board with plastic headed pins or masking tape.

(6) Coat platinotype emulsion with either a small buckle brush or airbrush.

(7) Dry over radiant heat until crackle dry, but do not overheat.

(8) Expose immediately in contact frame. Judge exposure by the appearance of shadow detail or use an actinometer for more accurate assessment.

(9) Mix platinotype developer—500 gm potassium oxalate dissolved in 1.5 gm of water.

(10) Heat developer until temperature reaches 27C (80F) and place print in dish. Development is instantaneous.

(11) Fix by passing print through three dishes of 1.5% hydrochloric acid at 5 min intervals.

(12) Wash print for 20 to 30 min in fresh running water and hang up to dry.

IRON PROCESS—KALLITYPE

(1) Plain size paper and prepare for print making.

(2) Mix kallitype sensitizer:

Ferric oxalate	1 level spoonful
Oxalic acid 10% solution	3 ,, ,,
Silver nitrate	½ ,, ,,
Distilled water	28 ml

Prepare in weak artificial illumination or bright safelighting.

(3) Pin sized paper onto drawing board with plastic headed pins or masking tape.

(4) Coat sensitizer onto paper with the aid of a buckle brush.

(5) Dry, as in the platinotype process.

(6) Expose, as in the platinotype process.

(7) Mix either of the following developers:
Sepia tone:

Potassium sodium tartrate	3 level spoonfuls
Potassium bichromate 10% solution	1 to 3 level spoonfuls
Distilled water	280 ml

Black tone:

Borax	6 level spoonfuls
Potassium sodium tartrate	4 ,, ,,
Potassium bichromate 10% solution	3 to 4 level spoonfuls
Water	280 ml

(8) Develop print for 5 min in weak artificial illumination or bright safelighting.

(9) Fix in a 5% solution of sodium thiosulphate in which ammonia of 0.880 specific gravity has been added at the rate of 2 level spoonfuls per 570 ml of fixer.

(10) Wash for one hour in running water. Use a hypo elimination bath for archival permanence and hang up to dry.

URANIUM PROCESS

(1) Plain size paper and prepare for printing.

(2) Mix uranium sensitizer:

Uranyl nitrate	6 level spoonfuls
Distilled water	170 ml

In weak artificial light or bright safelighting.

(3) Coat sensitizer with buckle brush or float paper on the solution.

(4) Hang up to dry in weak artificial illumination or bright safelighting.

(5) Place sensitized paper in contact frame with negative and expose until strong print-out image appears.

(6) Fix/develop in fresh running water when the highlights should clear.

(7) Hang up to dry in stream of warm air. The process is now complete, but further colour changes can be effected by toning procedures—see text.

PRIMULINE/DIAZO DYE PROCESS

(1) Fix-out an unexposed sheet of resin coated photographic paper in 20% solution of sodium thiosulphate. Wash and dry.

(2) Mix diazo presensitizer:

Primuline	3 level spoonfuls
Distilled water	1400 ml

(3) Soak RC paper in pre-sensitizer for 5 to 10 minutes.

(4) Remove RC paper and give brief rinse for a few seconds in clean water and hang up to dry in a stream of warm air.

(5) Mix diazo sensitizer:

Sodium nitrate	2 level spoonfuls
Oxalic acid	3 ,, ,,
Distilled water	1150 ml

(6) Soak presensitized RC paper in sensitizer and hang up to dry in a stream of warm air. Work in low level artificial illumination or bright safelighting.

(7) Place sensitized paper in the contact frame with a positive transparency and expose. Judge correct exposure by placing small sensitized paper off-cuts beside frame until they no longer give a colour when tested with the appropriate colour developer.

(8) Mix colour developers:

Blue:	Eikonogen	3 level spoonfuls
	Distilled water	1150 ml
Purple:	Alpha-naphthylamine	3 level spoonfuls
	Oxalic acid 20% solution	1 ,, ,,
	Distilled water	1150 ml
Yellow:	Carbolic acid	2 level spoonfuls
	Distilled water	1150 ml
Orange:	Resorcinol	1 level spoonful
	Sodium hydroxide	2 ,, ,,
	Distilled water	1150 ml
Brown:	Pyrogallic acid	3 level spoonfuls
	Distilled water	1150 ml
Red:	Beta naphthol	1 level spoonful
	Sodium hydroxide	2 ,, ,,
	Distilled water	1150 ml

(9) Develop print in chosen colour.

(10) After development rinse print in 5% solution of tartaric acid and hang up to dry.

DYE MATRIX MANUFACTURE

(1) Attach kodatrace to emulsion coating frame as used in carbon tissue manufacture, matt side up.

(2) Mix matrix coating:

Gelatin powder	5 level spoonfuls
Glycerine	1 ,, ,,
Sugar	1 ,, ,,
Ammonium bichromate	1 ,, ,,
Distilled water	110 ml

Soak gelatin for two hours in the cold distilled water, after which slowly warm to 38–43C (100–110F), then add the glycerine, sugar and ammonium bichromate and thoroughly mix.

(3) Pour gelatin into coating frame until half full, then immediately pour back into jug.

(4) Place frame in a cool level position and allow to set.

(5) When set, unclamp frame and hang kodatrace up to dry in warm, but not hot, air, 27C (80F) maximum. Mixing, coating and drying must be carried out in weak artificial illumination or bright safelighting.

(6) Place sensitized matrix material in contact printing frame and expose through the back of the kodatrace with the aid of a negative.

(7) Judge correct exposure by test strip or actinometer.

(8) Soak matrix in hot water at 38–43C (100–110F). Lath off the unexposed gelatin with the fresh hot water—2 to 3 min should suffice.

(9) Transfer matrix into a dish of cold water.

(10) Fix in dish containing 2% potassium alum and a few drops of wetting agent. Remove after 30 sec and hang up to dry.

(11) When dry, the matrix can be stored for future dye transfer, or used straight away for print production.

(12) Print production follows the classic Kodak inhibition process. All relevant information is contained in Kodak Technical Booklet E80 entitled *The Kodak Dye Transfer Process*.

Bibliography

Due to the explosion of books on photography during the past decade, and the current trend, particularly in America, of facsimile reproduction of antique books and periodicals, a complete bibliography is almost impossible. Therefore, the author has only included books which have been of direct use to him in the compiling of this book. Many of the works are out of print, but can still be obtained from libraries. The library of the Royal Photographic Society is extremely useful in this respect.

There is bound to be some overlapping of information in books referred to in a number of subject areas. These have been classified where they are thought to be most useful to the reader.

Chapter One and General

Blaxland-Stubbs S G *Modern Encyclopedia of Photography*
The Waverley Book Co. Ltd. 1938
Clerc L P *Photography, Theory and Practice*
Focal Press 1973
Focal Encyclopedia of Photography
Focal Press 1977
Hedgecoe J and Langford M *Photography Materials and Methods*
Oxford University Press 1971
Jones B E *Cyclopedia of Photography*
The Waverley Book Co. 1911
Molly E *Practical Photography*
George Newnes Co. 1935
Neblette C B *Photography, Its Materials and Processes*
D. Van Nostrand Co. Inc. 1973
Petersons *Guide to Creative Darkroom Technique*
Petersons Publishing Co. 1973

Pittaro E M Photo-Lab Index *The Cumulative Formulary of Standard Recommended Photographic Procedures*
Morgan & Morgan, New York, 1977
Sowerby A L M *Dictionary of Photography*
Iliffe and Sons Ltd.
Spencer D A *Focal Dictionary of Photographic Technoloqies*
Focal Press 1973
Wall E J *Photographic Facts and Formulas*
American Photographic Publishing Co. 1947

Chapter Two

Beattie K W *The Magic of Making Halftones*
Litho Book, New Jersey, distributed UK Wogill Ltd. 1959
Gasson A *Handbook for Contemporary Photography*
Light Impressions Corp., New York, 1977
Howall W *Making Pictures with Paper Negatives*
Chapell, London, 1938
Kodak *Contact Screens Types and Applications* (Q21)
Kodak Ltd
Peel Fred *Paper Negatives* (Technical Report)
Loan photocopy *Paper Negatives* (Technical Report)
Loan photocopy *Royal Photographic Society* 1941
Tait Jack *Beyond Photography*
Focal Press 1979

Chapter Three

Barnet *Book of Photography*
Elliott and Sons, Barnet, Herts. 1898
Bunnel P *Non Silver Printing Processes*
Four selections 1886—1972, Arno Press, New York, 1973
Doty R *Photo Secession*
George Eastman House 1960
Jacobson C I *Home Made Papers and Plates*
Focal Press Pamphlet, London 2nd world war edition
Jay B *Robert Demachy*
St. Martins Press, New York, 1974
Kosar J *Light Sensitive Systems, Chemistry and Application of Non-Silver Photographic Processes*
Wiley & Sons Inc., New York, 1965
Sinclair J *Sinclair Handbook of Photography*
James Sinclair and Co. Ltd., London, 1913
Williams T I *Pigment Printing Processes*
Royal Photographic Society Publications, 1978

Chapter Four

Gareis, Schelrer *Creative Colour Photography*
Fountain Press, London, 1970
Gaunt W *The Observers Book of Modern Art*
Frederick Warne & Co. Ltd, London, 1964
Life Library of Photography *Colour*
Time-Life Books (Nederland) NV, 1970

Chapter Five

Gernsheim H and A *Alvin Langdon Coburn Photographer*
Faber and Faber, London, 1966
Harrison F J *The International Annual of Anthoney's Photographic Bulletin*
Percy Lund & Co., London, 1894
Lewis Eleanor *The Darkroom George Tice*
Lustrum Press Inc., New York, 1977
Life Library of Photography *Light and Film* and *Caring for Photographs*
Time-Life Books (Nederland) NV, 1970
Palder E L *Magic with Photography*
William Collins Sons Co. Ltd, London, 1971
Rexroth N *The Platinotype 1977*
Light Impressions, 1977
Stieglitz A *Camera Work 1903–1917*
reprinted New York, Bergmans, 1966

Chapter Six

Duncan C *Amateur Photography*
George Newnes Ltd, London, 1945
Jerome A *Crayon Portraiture*
Baker and Taylor Co., New York, 1892
Wall A H *A Manual of Artistic Colouring as Applied to Photographs*
Arno Press (Facsimile Reproduction) New York, 1973
Wally C W *Colouring Tinting and Toning Photographs*
Fountain Press, London, 1944

Chapter Seven

Coote J H *Colour Prints*
Focal Press, London, 1974
Croy O R *The Complete Art of Printing and Enlarging*
Focal Press, London, 1976

Diazo Processes for Drawing Office and Technical Reproduction
Ozalid Co.
Hanworth Viscount *Amateur Dye Transfer Prints,*
Focal Press Ltd, London, 1955
C80 Kodak Dye Transfer Process (Technical Pamphlet)
Kodak Ltd, London
Lewis E *Darkroom Betty Hann*
Lustrum Press Inc, New York, 1977

Chapter Eight

Berger J *Ways of Seeing*
BBC Publications, London
Blaxland-Stubbs S G *The Modern Encyclopedia of Photography Vol. 2*
The Waverley Book Co. Ltd, 1938
Campbell B *Exploring Photography*
BBC Publications, London, 1978
Coke F, Van Daren *The Painter and the Photograph*
University of New Mexico, Albuquerque, 1970
Croy O R *Design by Photography*
Focal Press, London, 1971
Evans H and M *Sources of Illustration*
Adams and Dart, Bath, 1971
Evans H and M and Nelki A *Picture Researchers' Handbook*
David Charles, Newton Abbot, 1975
Gernsheim H *Creative Photography, Aesthetic Trends 1839–1960*
Faber and Faber, London, 1962
Gombrich E *Art and Illusion*
Phaidon Press, London, 1960
Heartfield John *Photomontages*
Arts Council of Great Britain, London, 1969
Kostelanetz *Moholy-Nagy*
Praeger, New York, 1970
McLuhan M *Understanding Media*
Routledge 1964
Moholy-Nagy *Painting, Photography, Film*
Lund Humphries, London, 1969
Nash Paul *The Fertile Image*
Faber and Faber, London, 1951
Scharf A *Art and Photography*
Penguin Books, London, 1974
Taylor J *Pictorial Photography in Britain 1900–1920*
Arts Council of Great Britain
Woodhead Harold C *Creative Photographic Printing Methods*
Focal Press 1975

Index

151

155